CREATIVE CRYPT
THE ART OF TOM WILLIAMS
2013-2015

HELLO AND WELCOME TO CREATIVE CRYPT,
THIS IS A SELECTION OF 'PERSONAL FAVOURITES' FROM BETWEEN
2013 TO 2015, HOPEFULLY IT SHALL SERVE AS A KIND OF JOURNAL
OF MY EVER LEARNING ART JOURNEY.

ANYWAY, TIME TO PIPE DOWN AND LET YOU ENJOY MY BOOK,

TOM

*PLEASE NOTE SOME OF THE PIECES WITHIN THIS BOOK
HAVE PREVIOUSLY BEEN RELEASED IN "ADVENTURES
IN INK" VOLUME 1 AND 2.

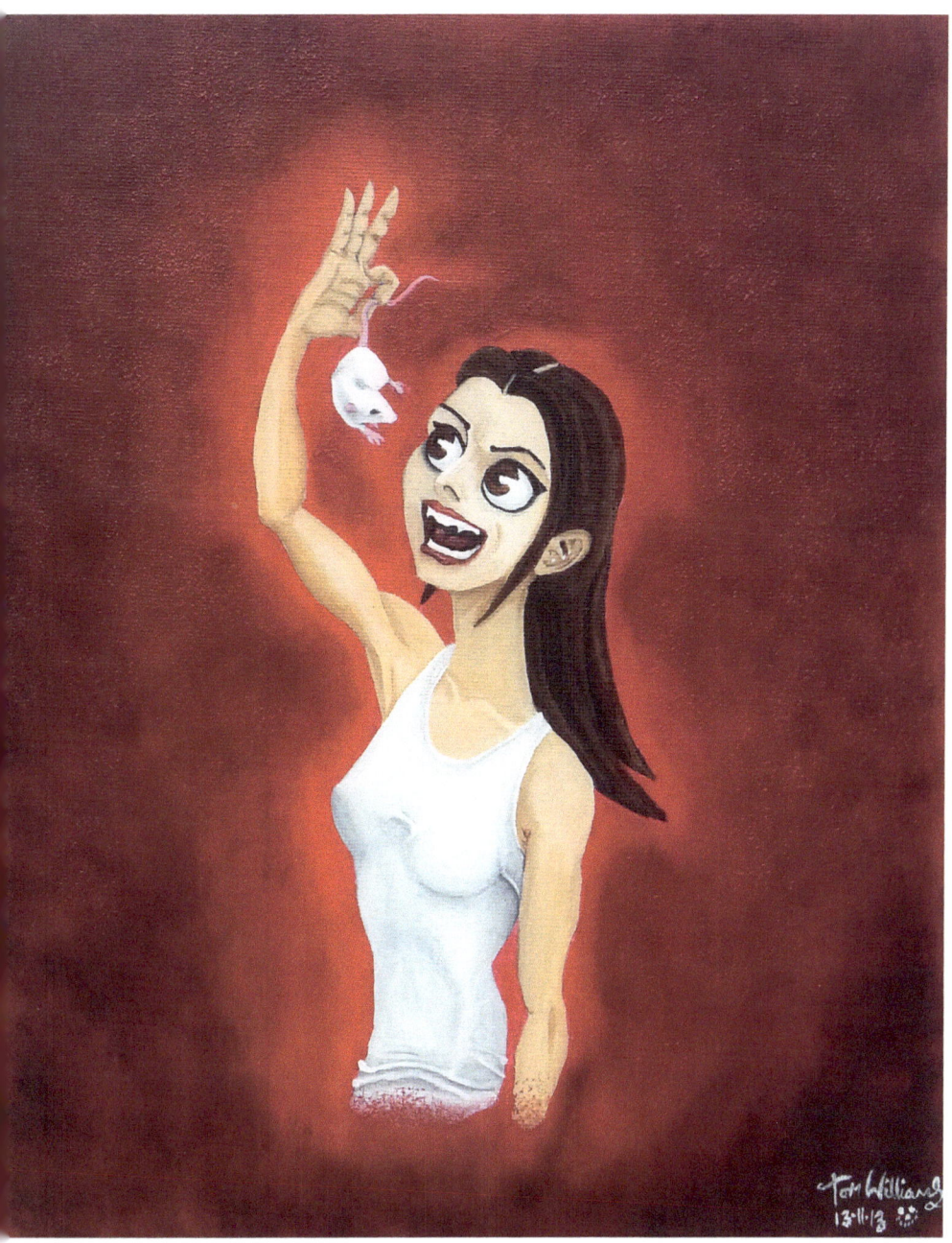

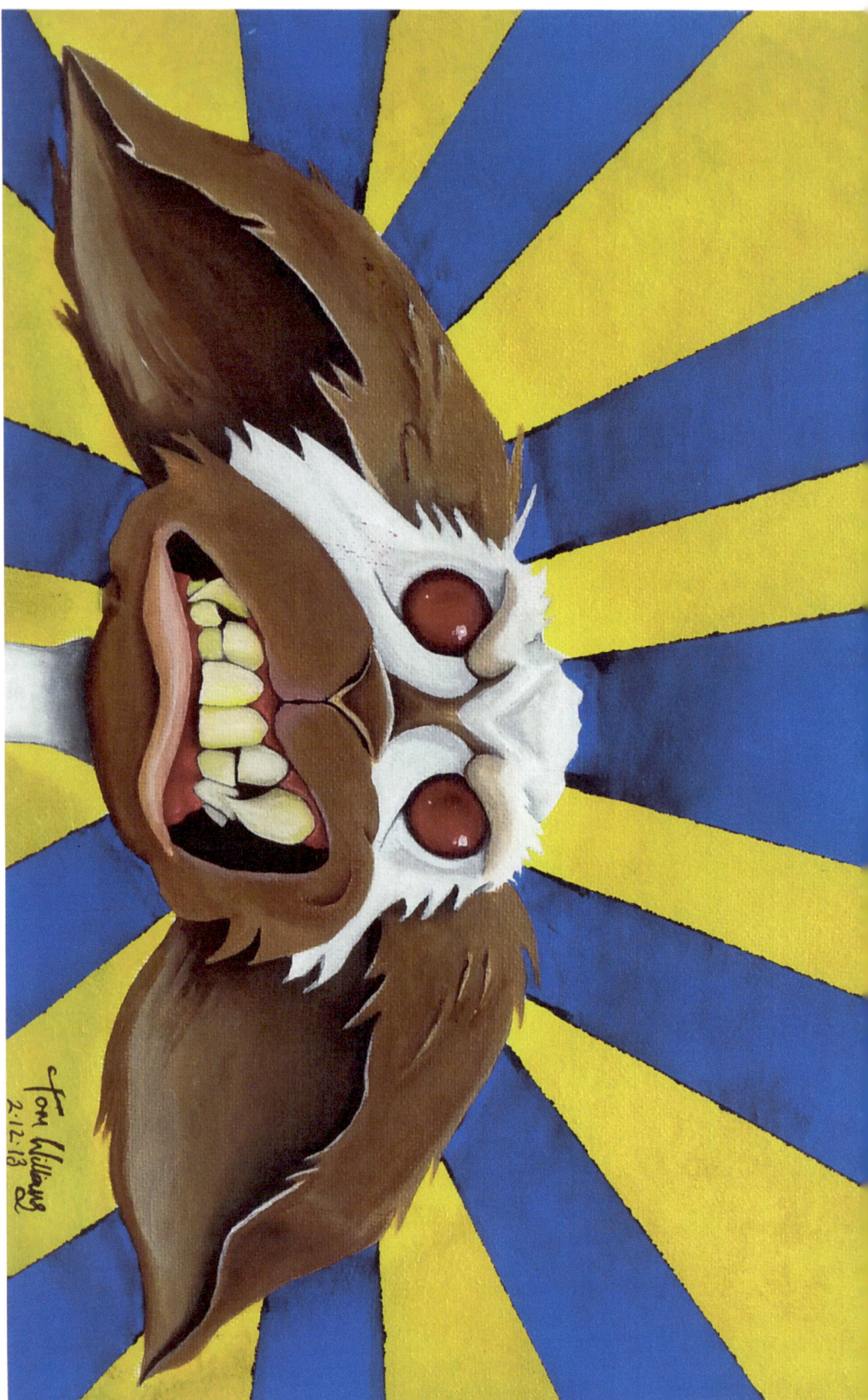

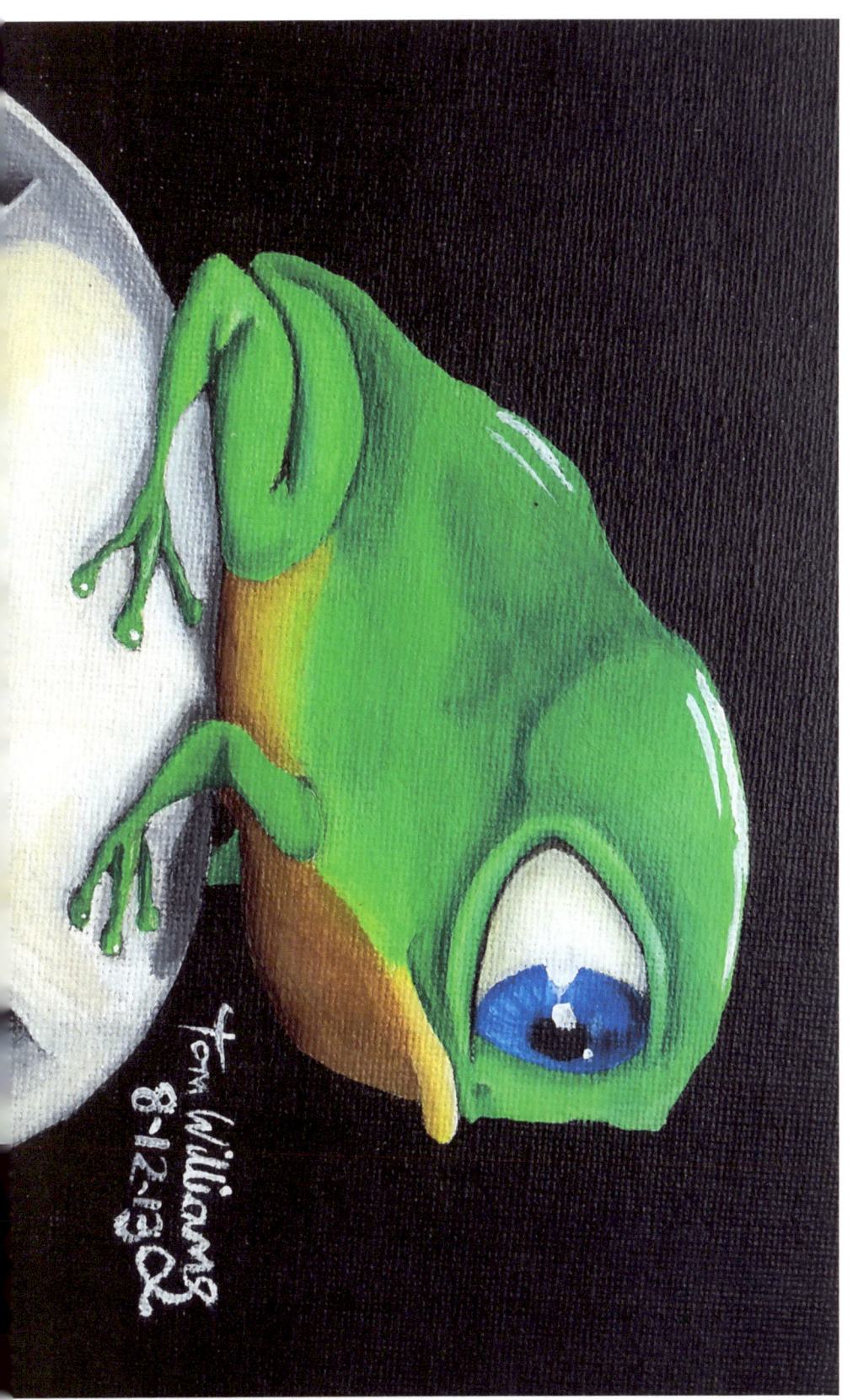

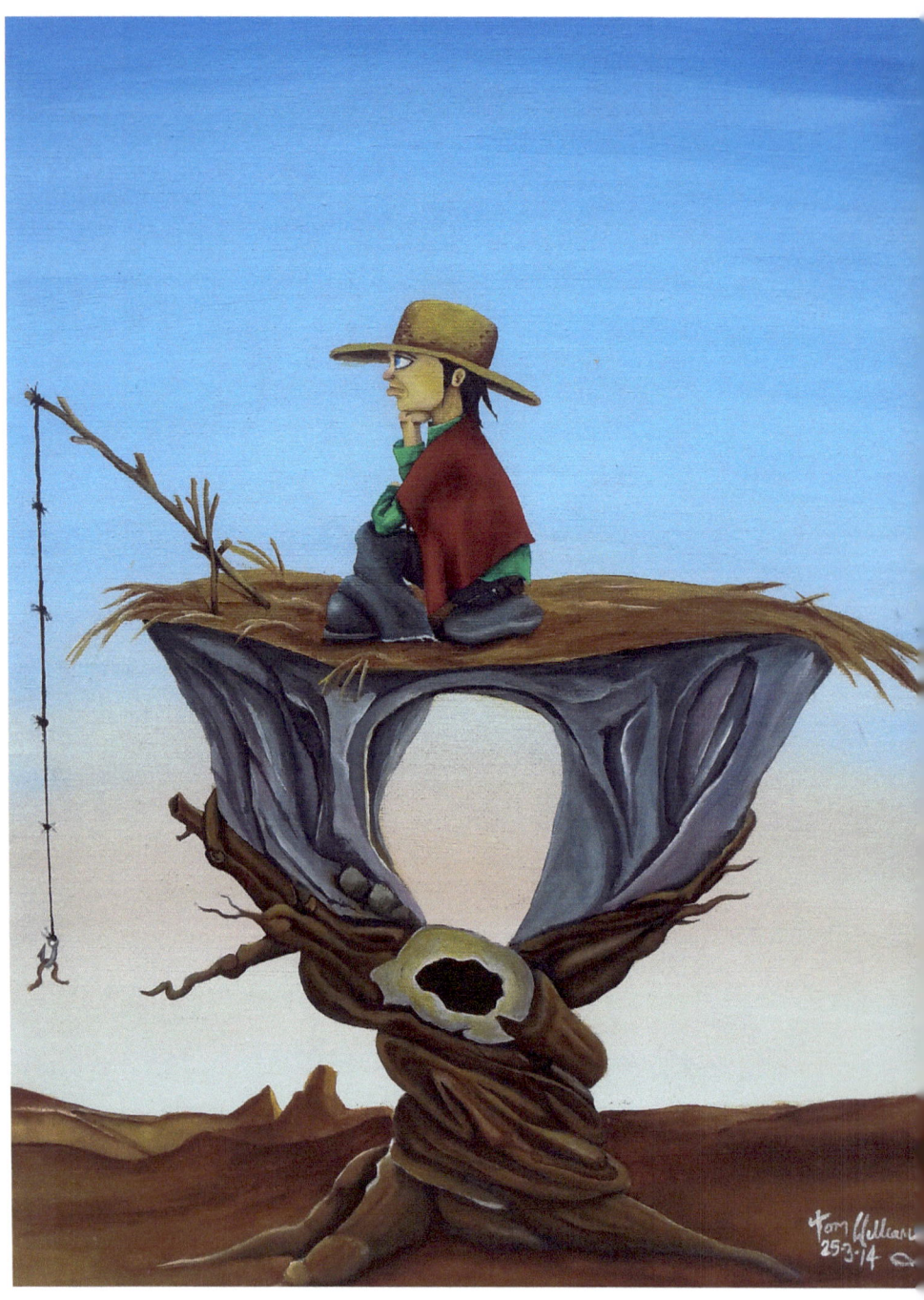

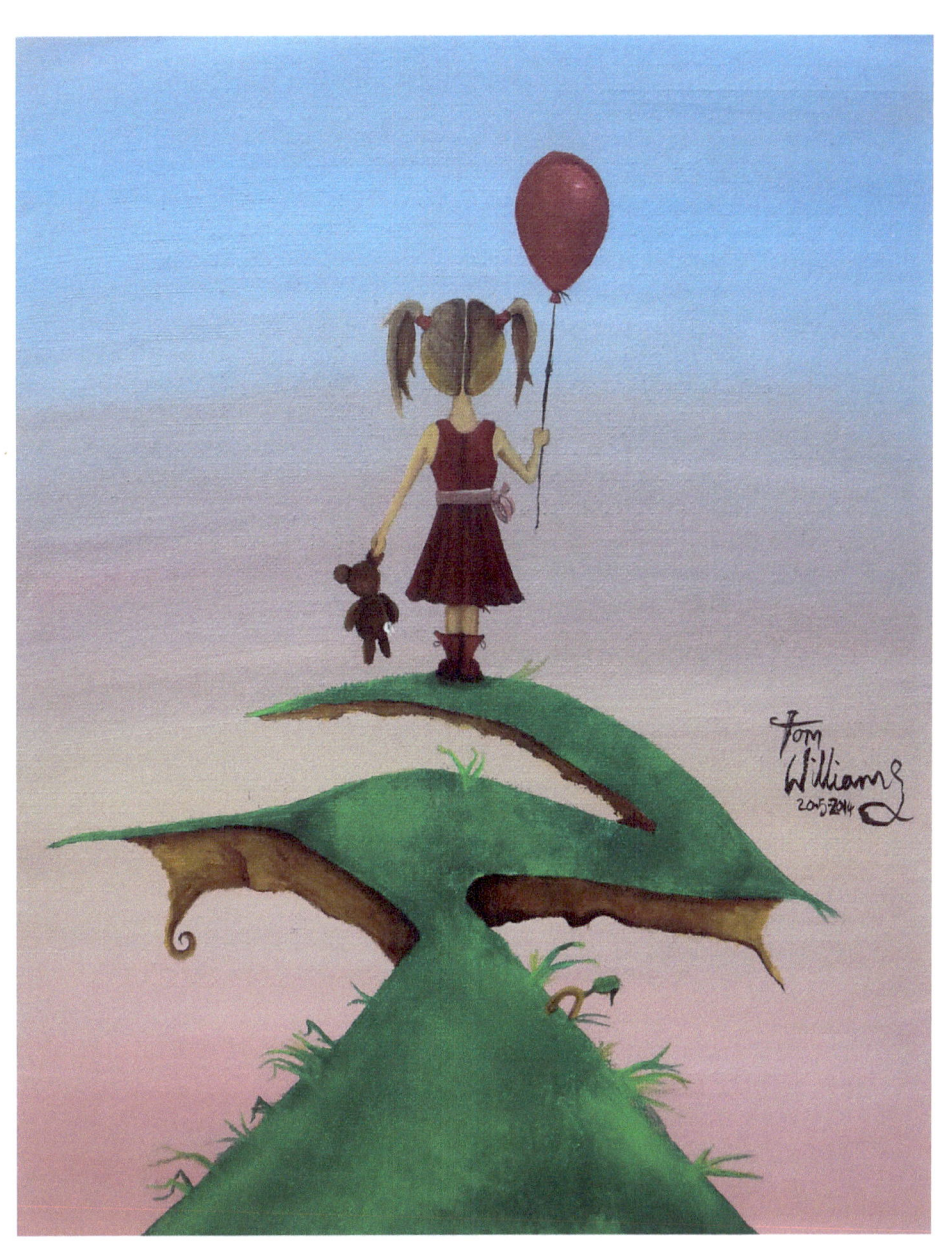

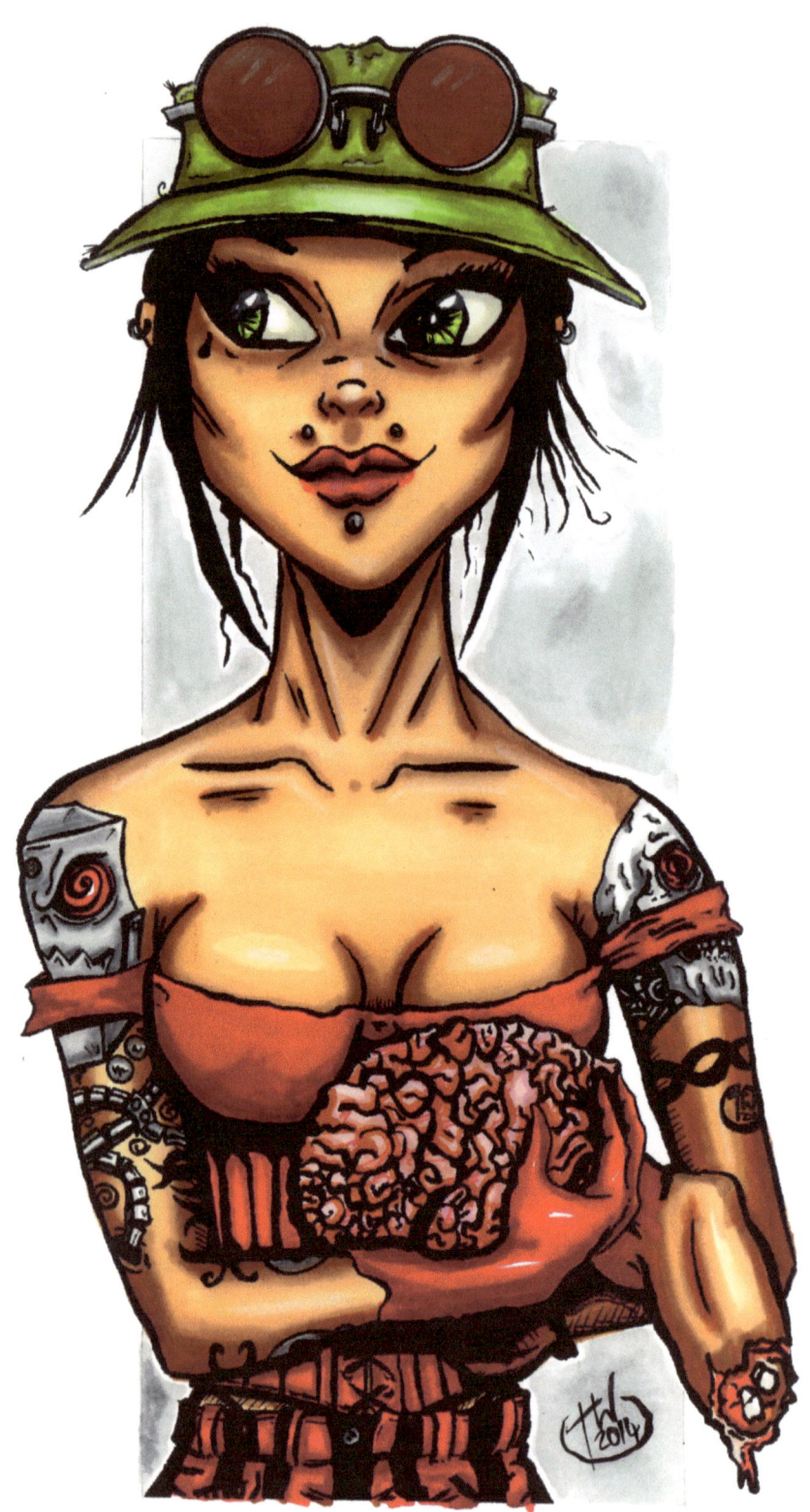

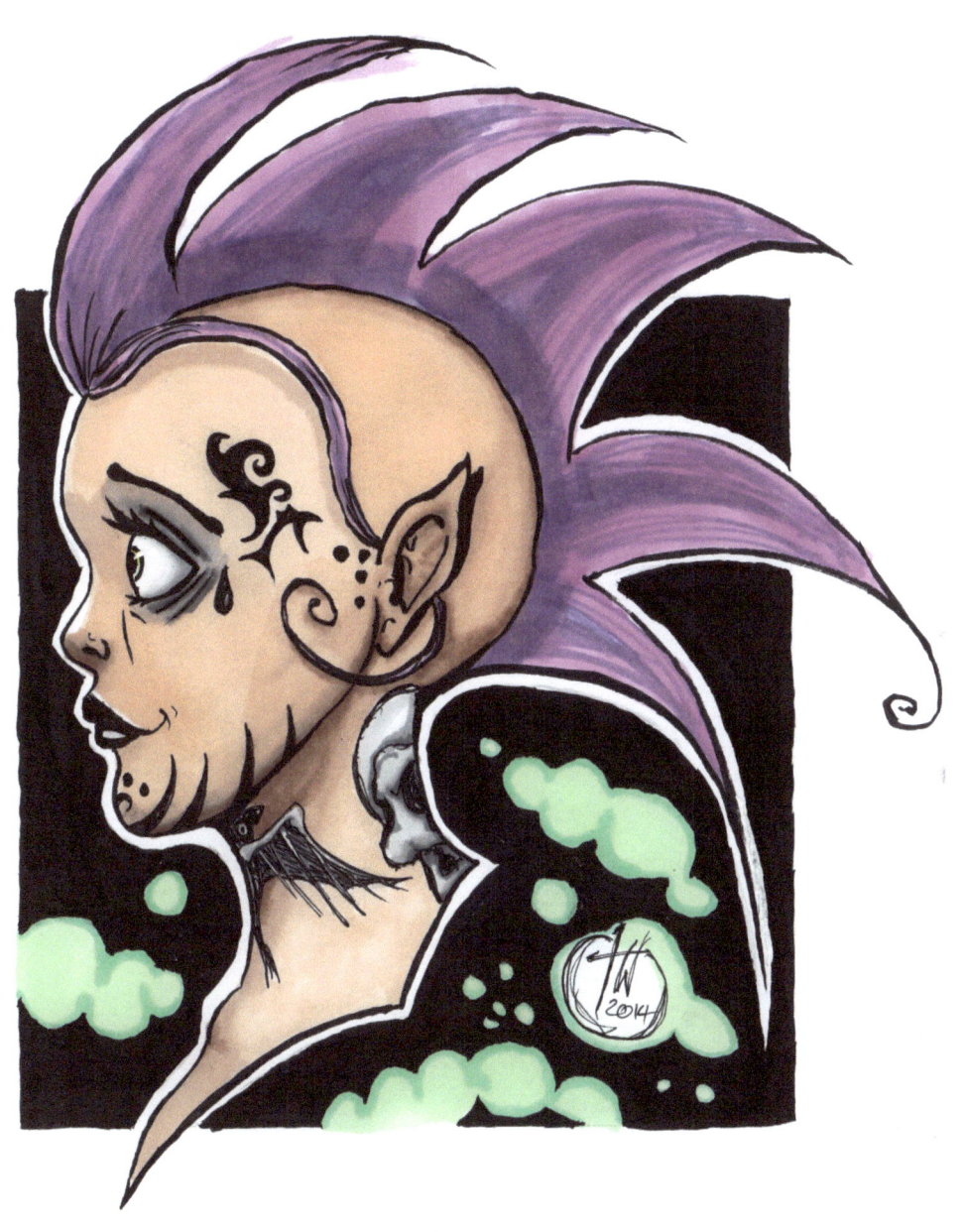

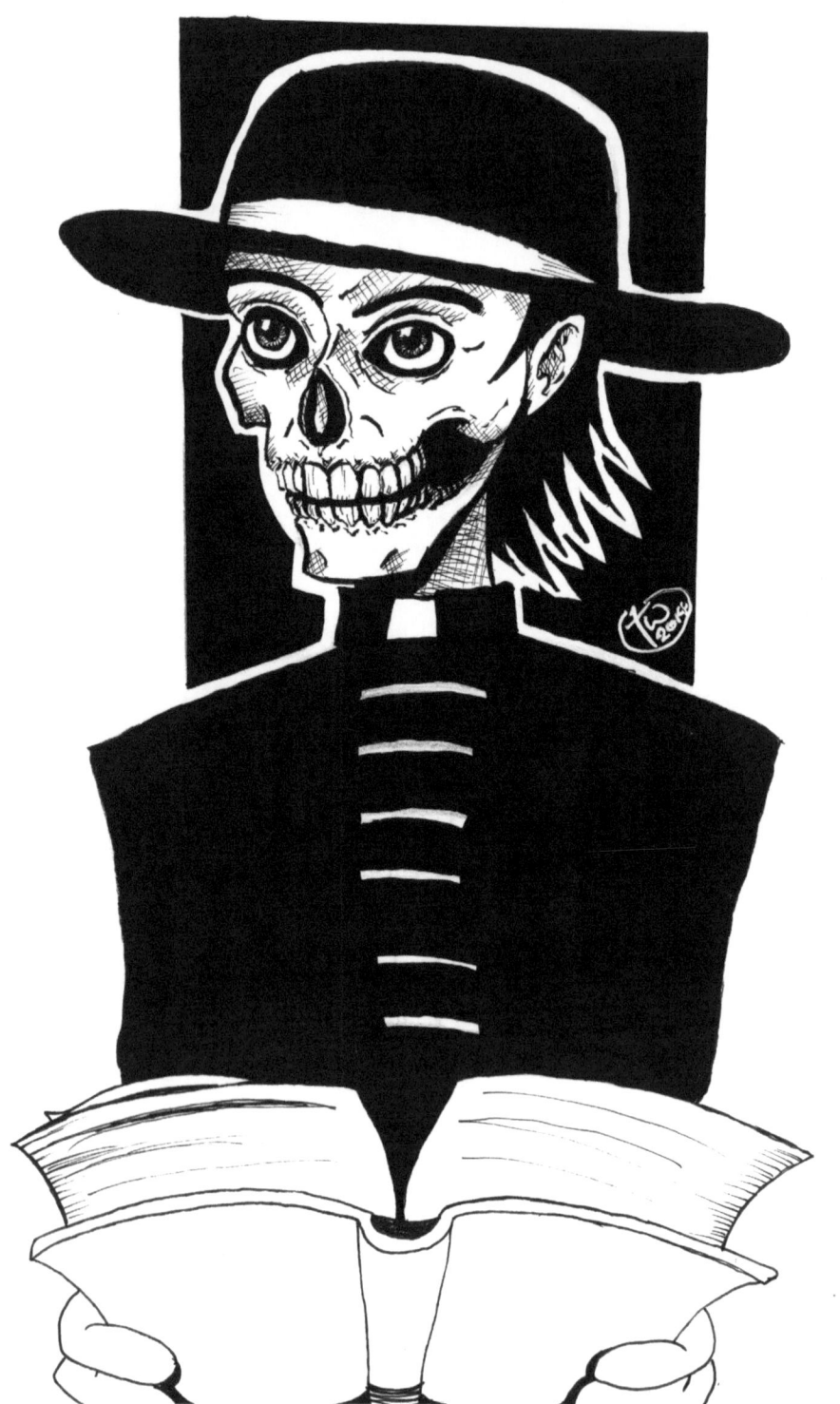

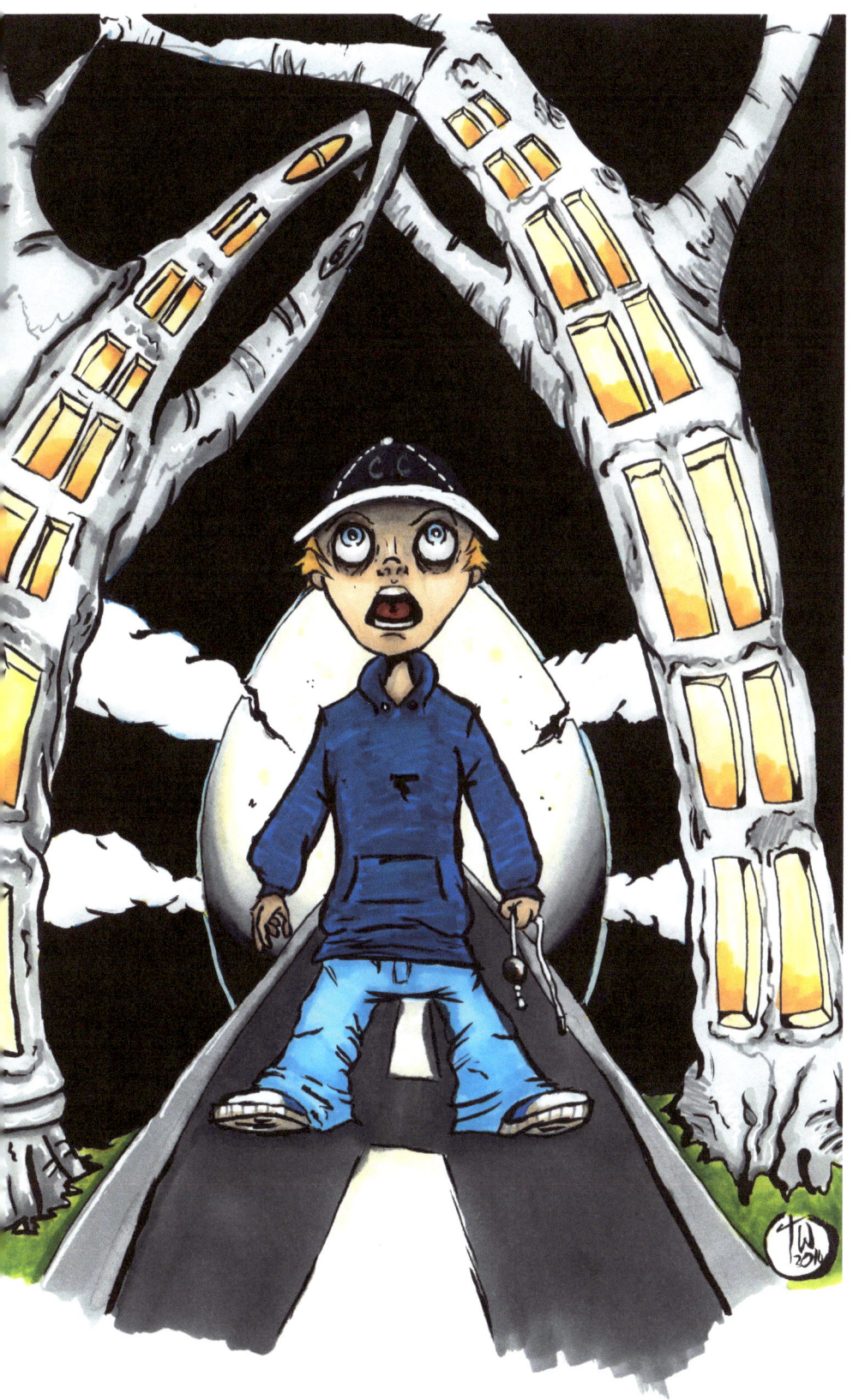

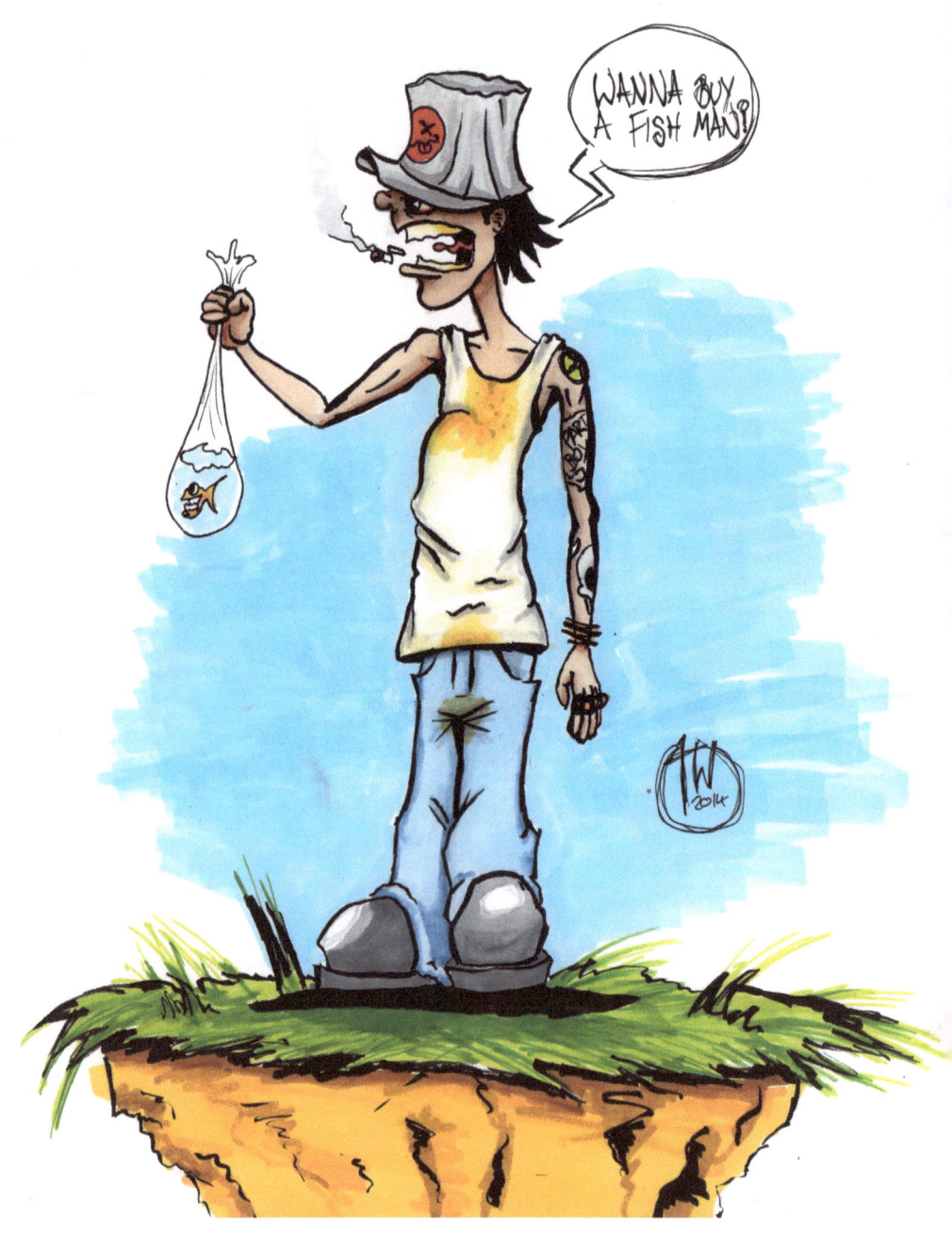

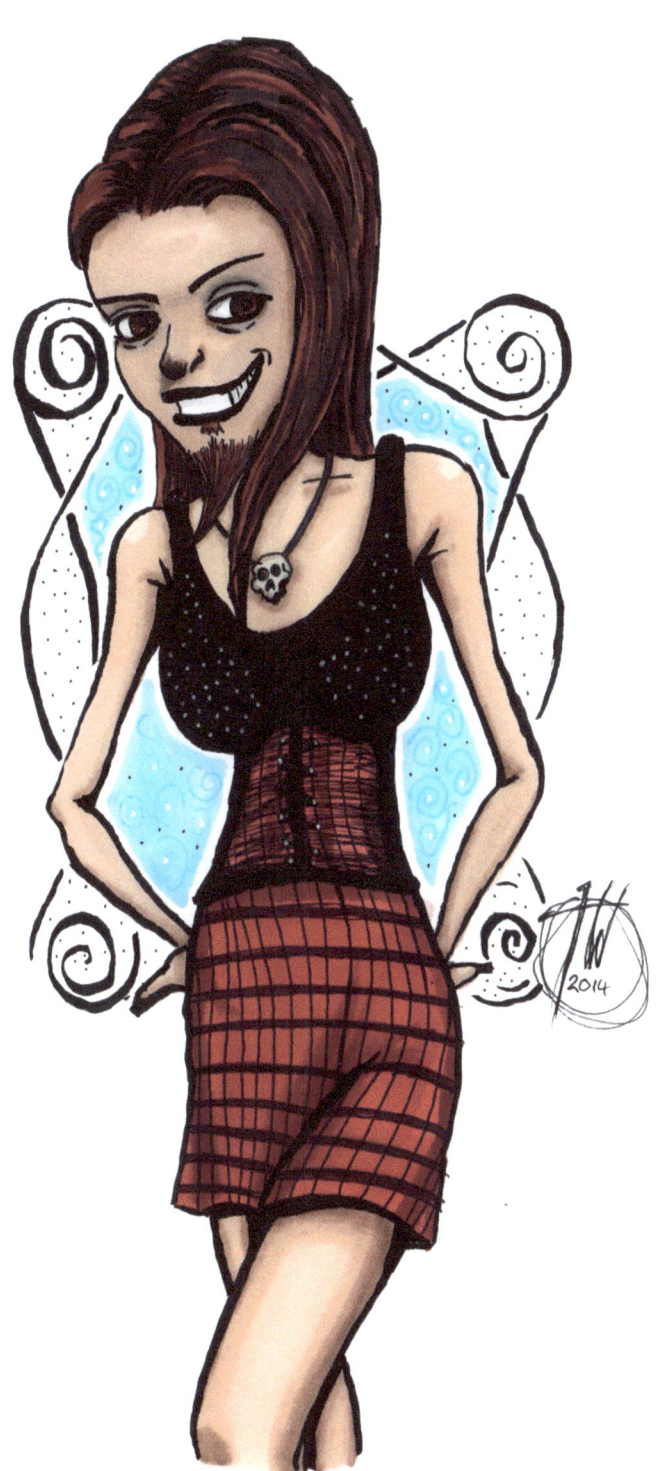

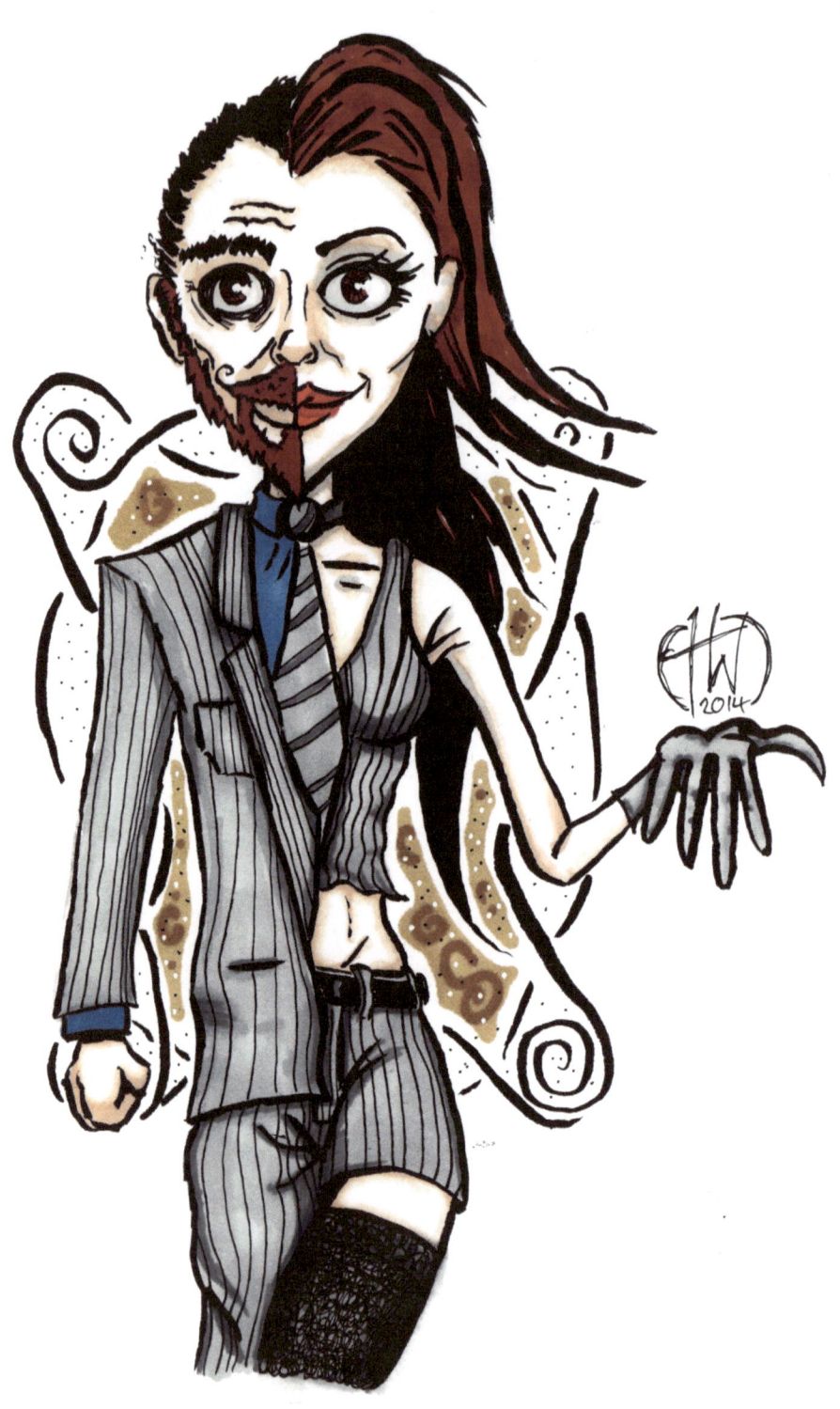

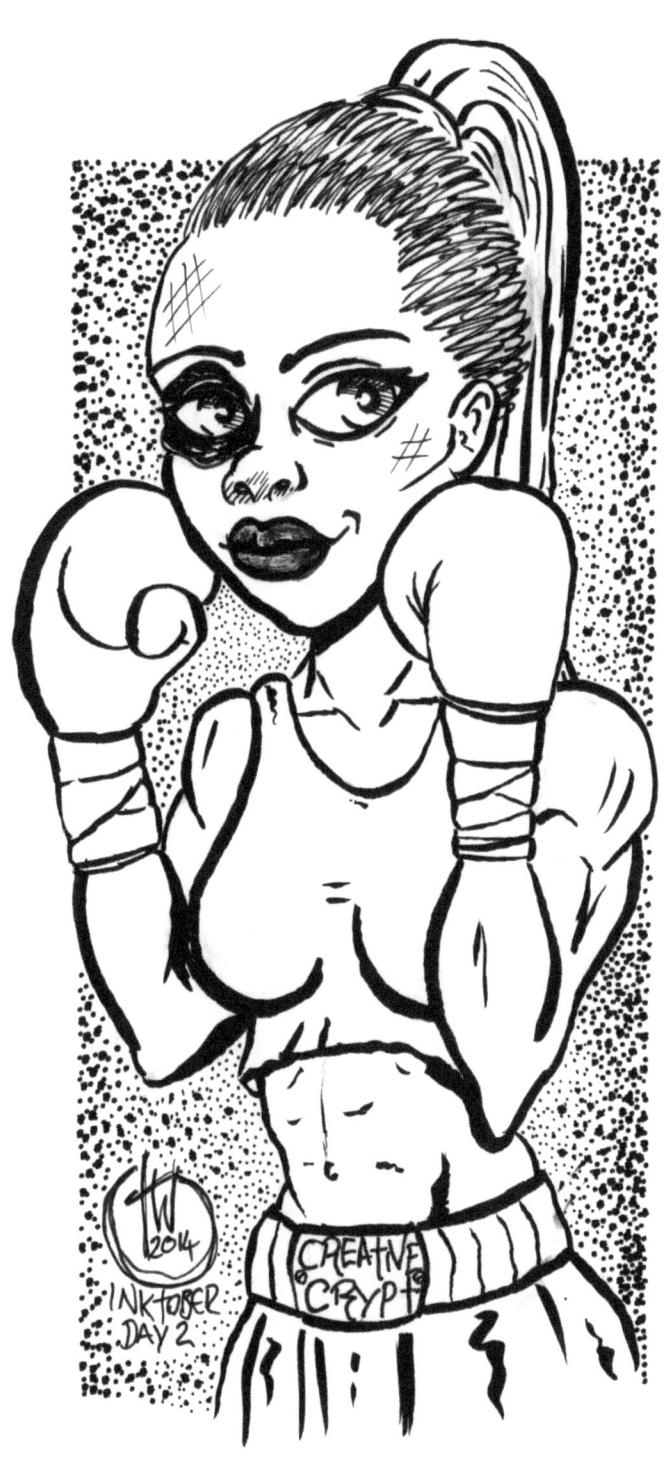

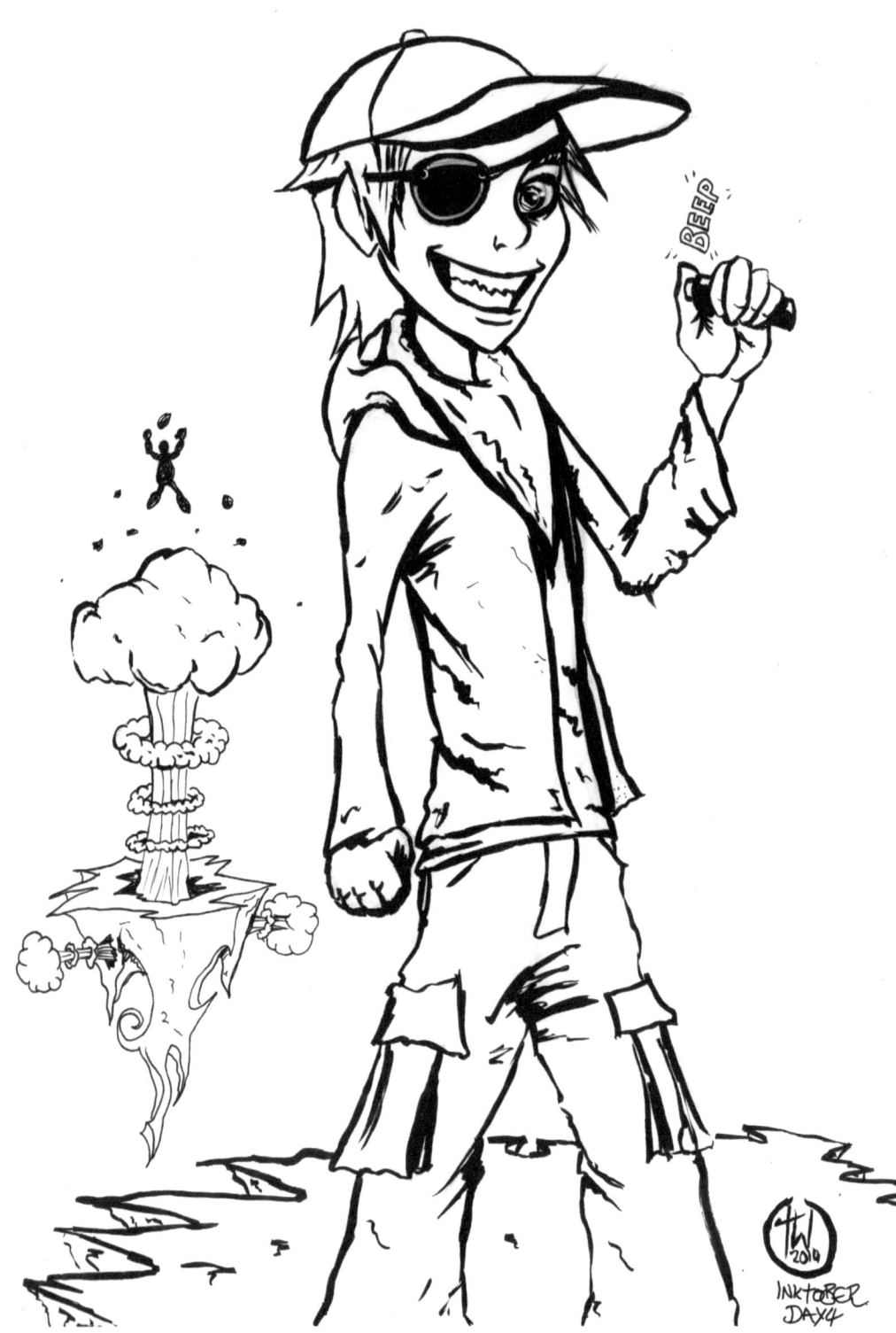

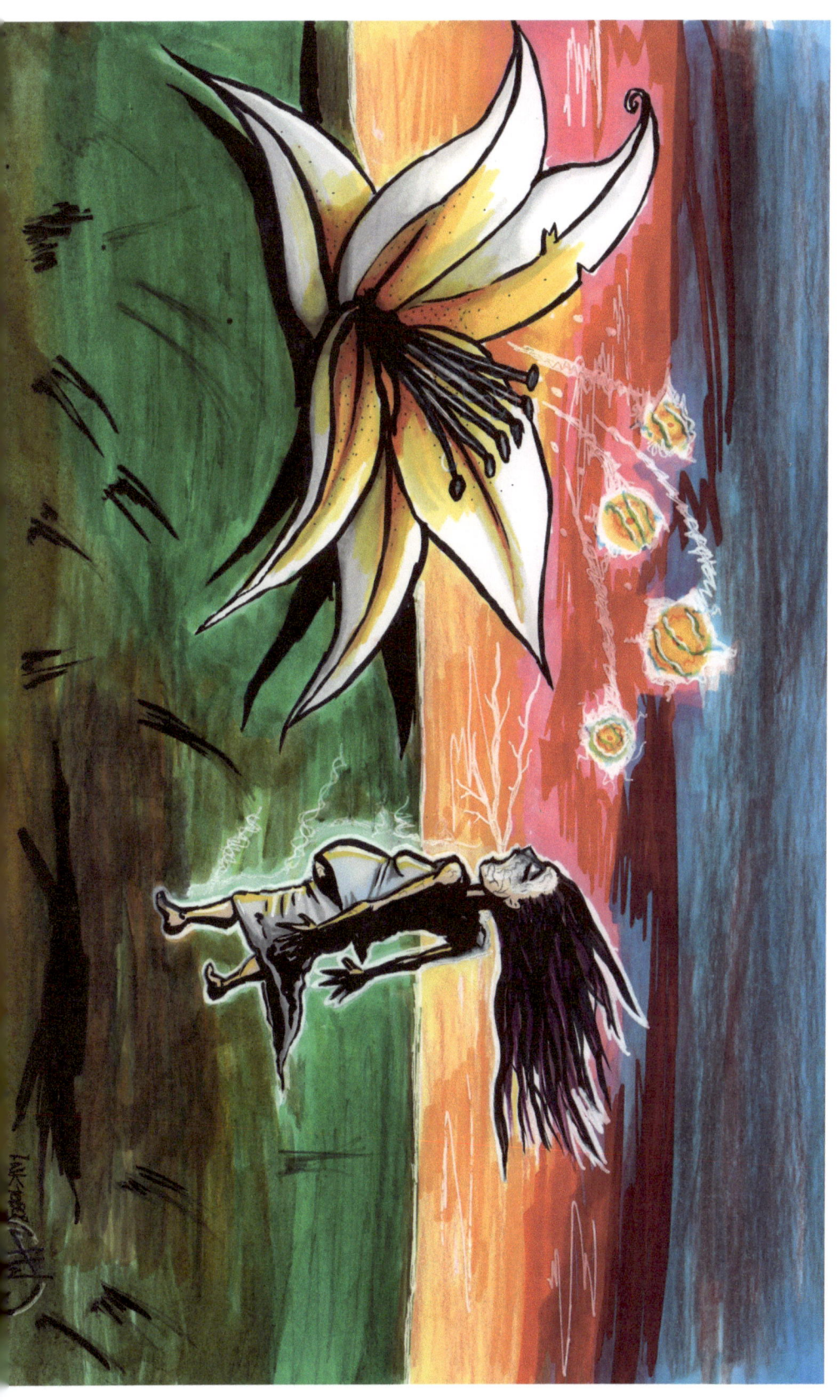

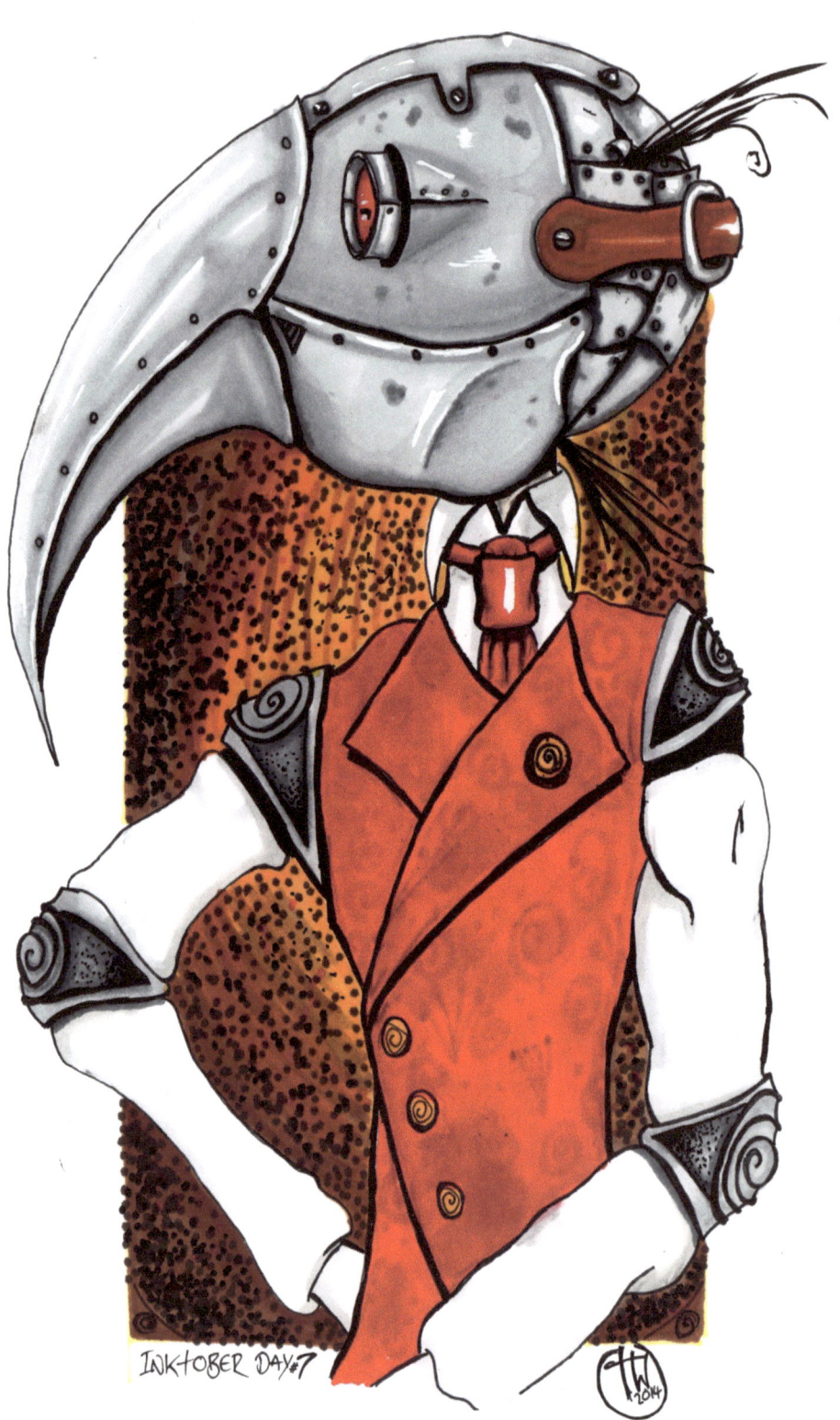

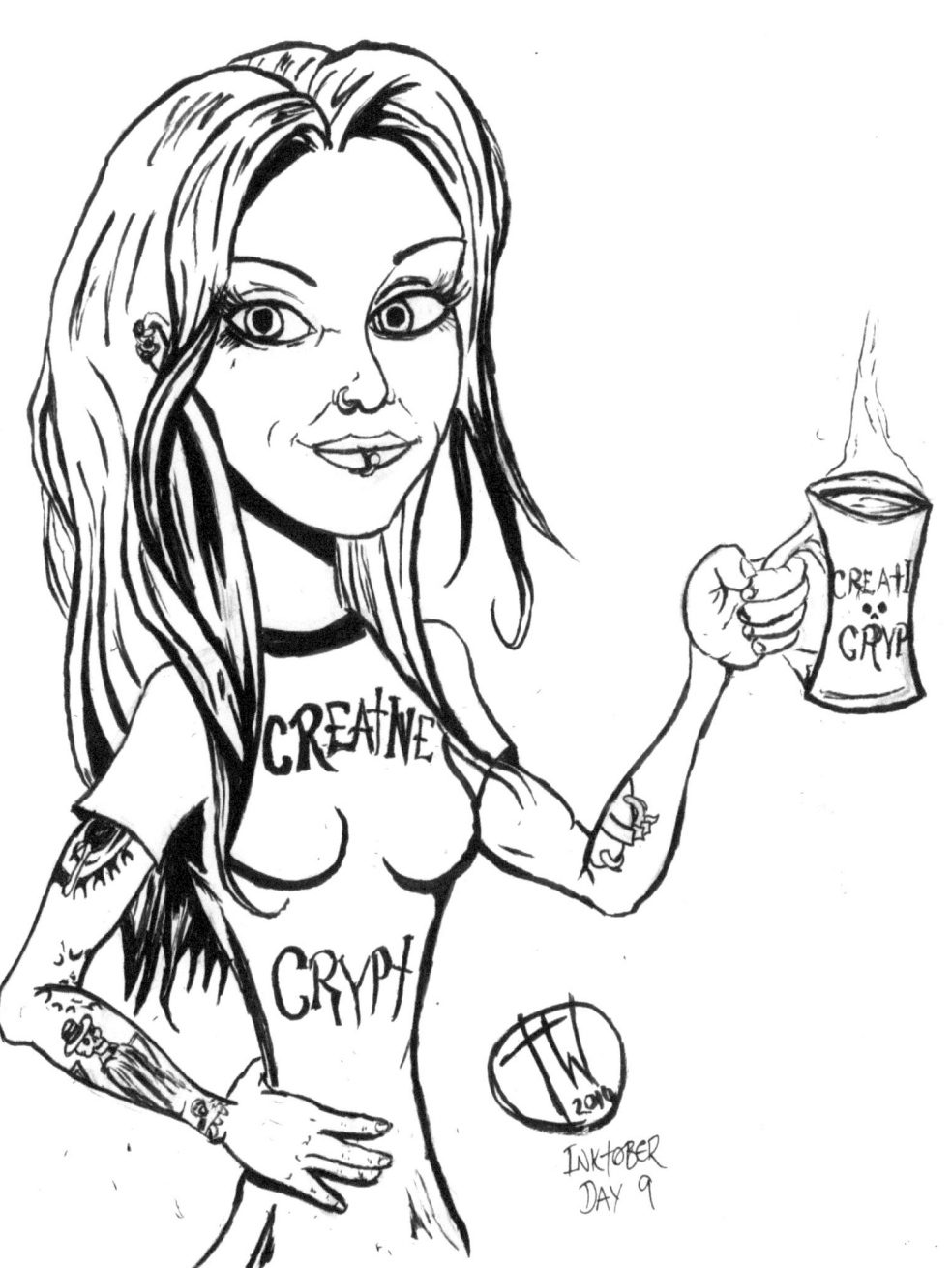

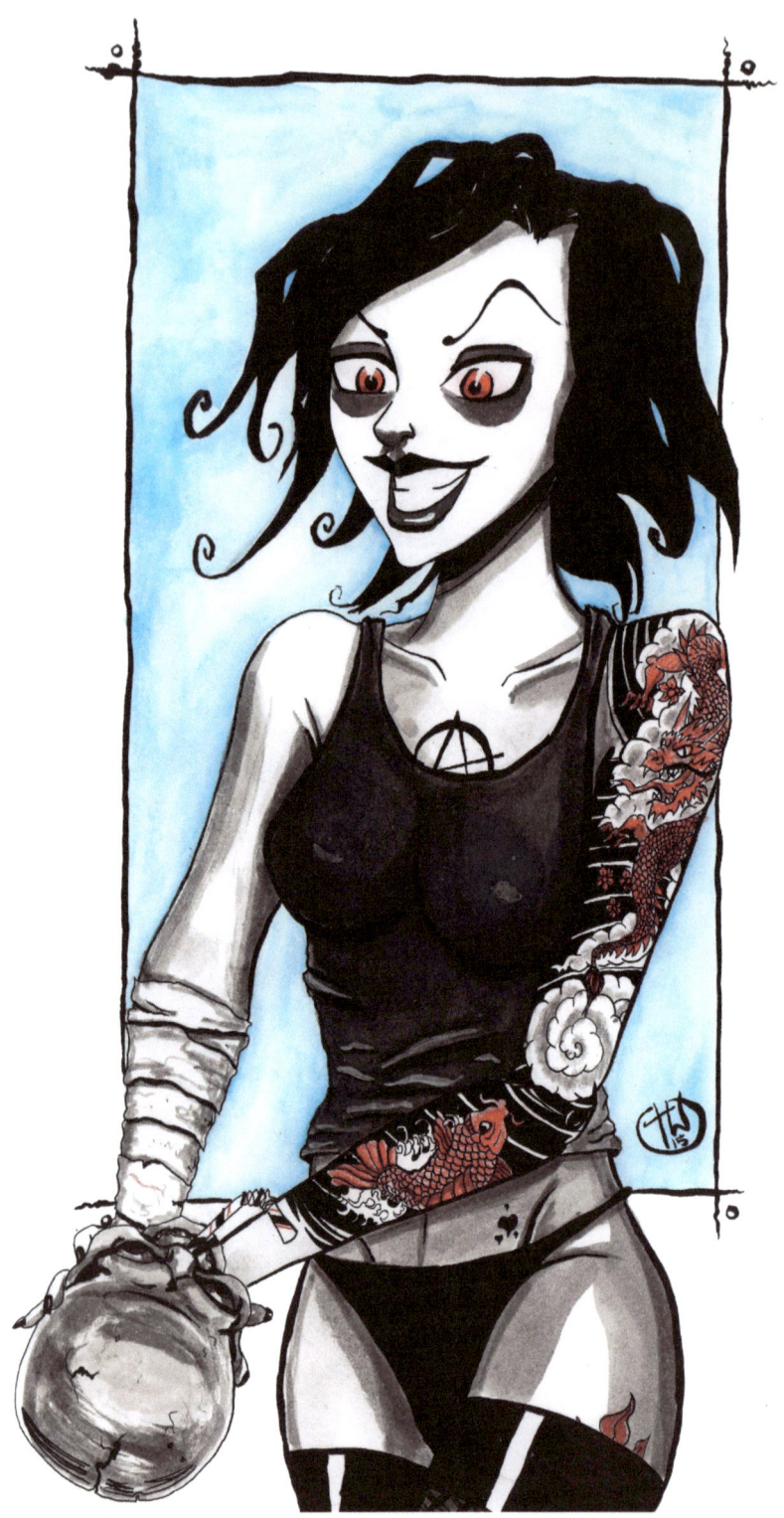

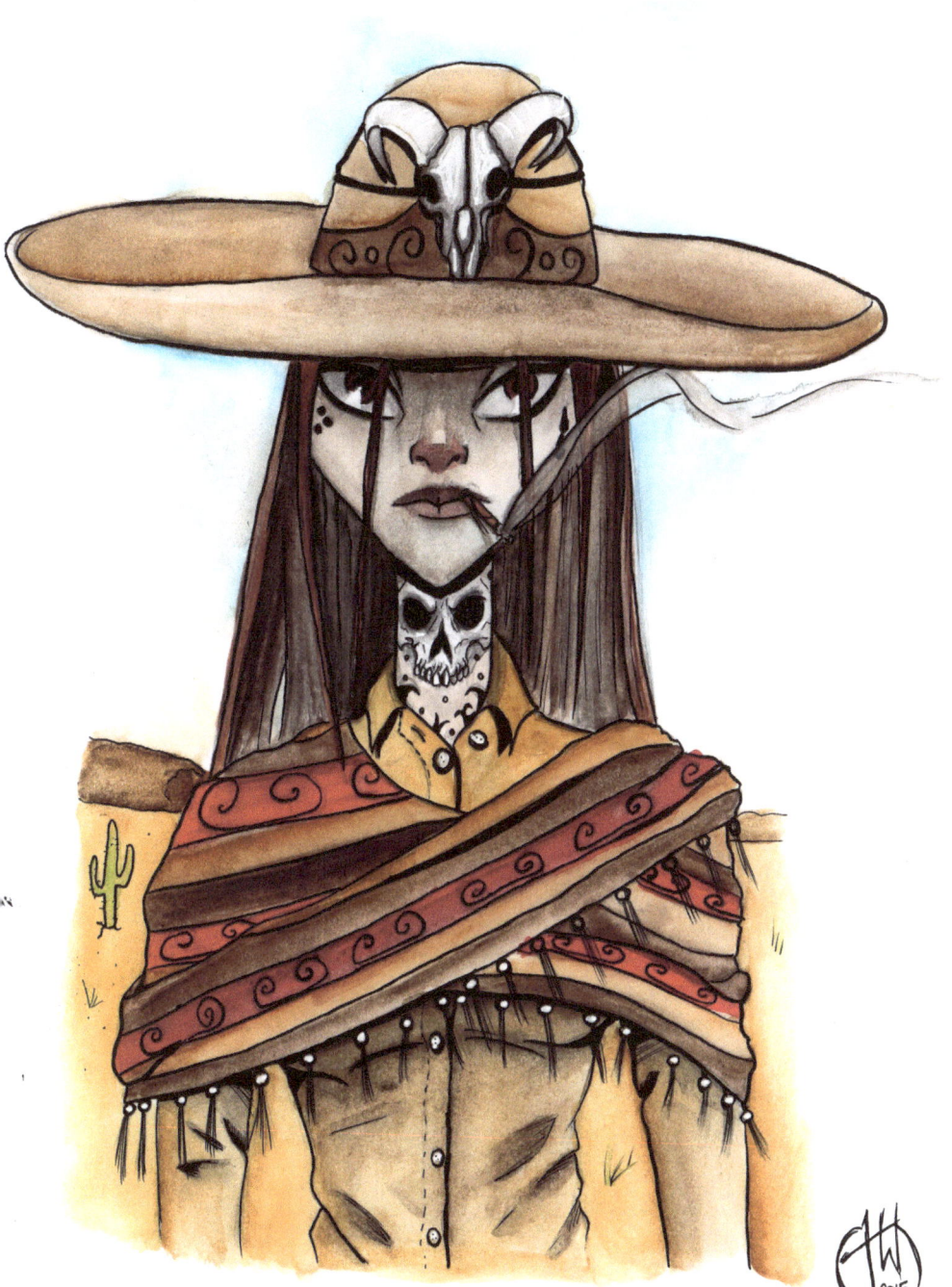

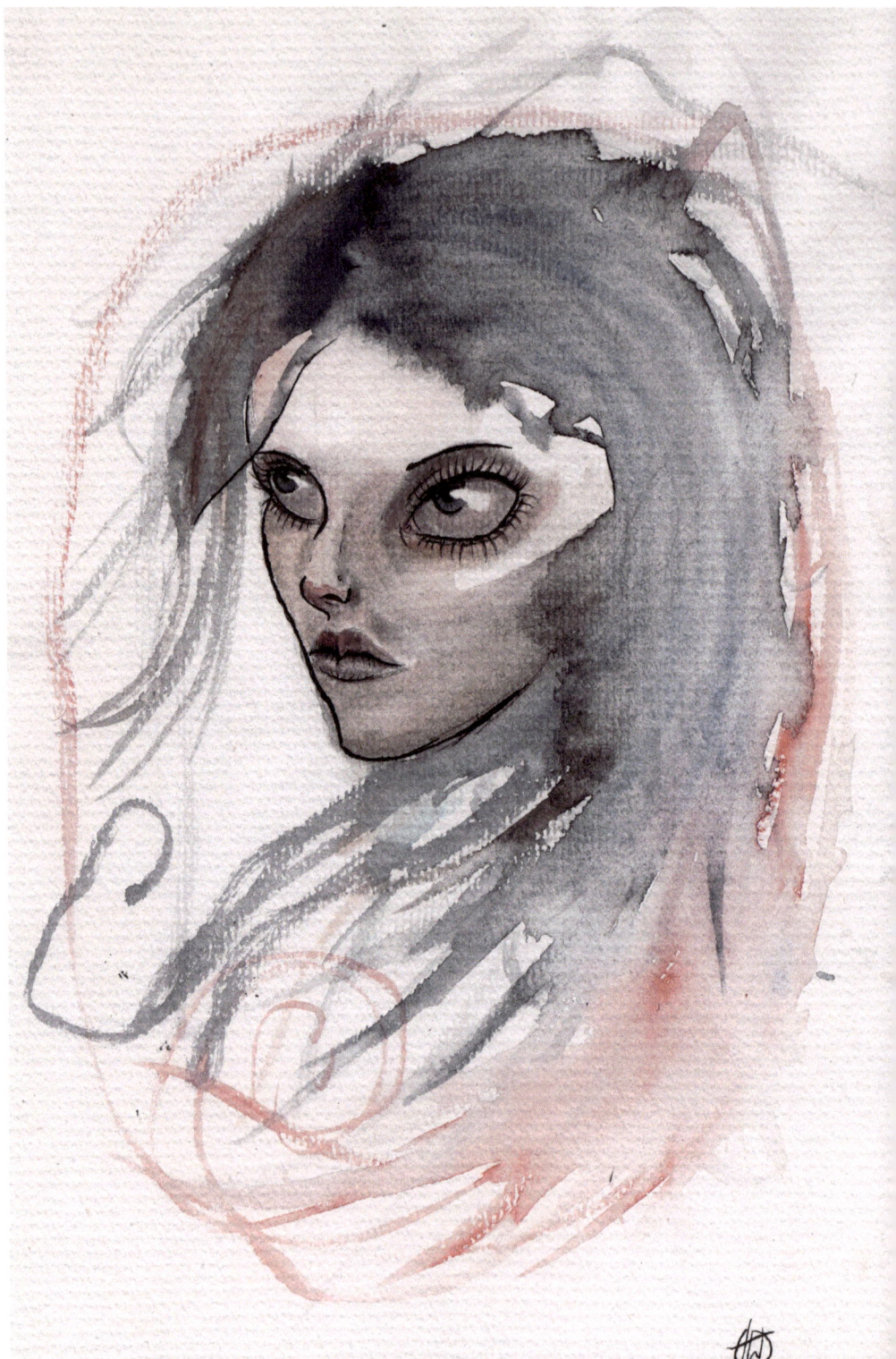

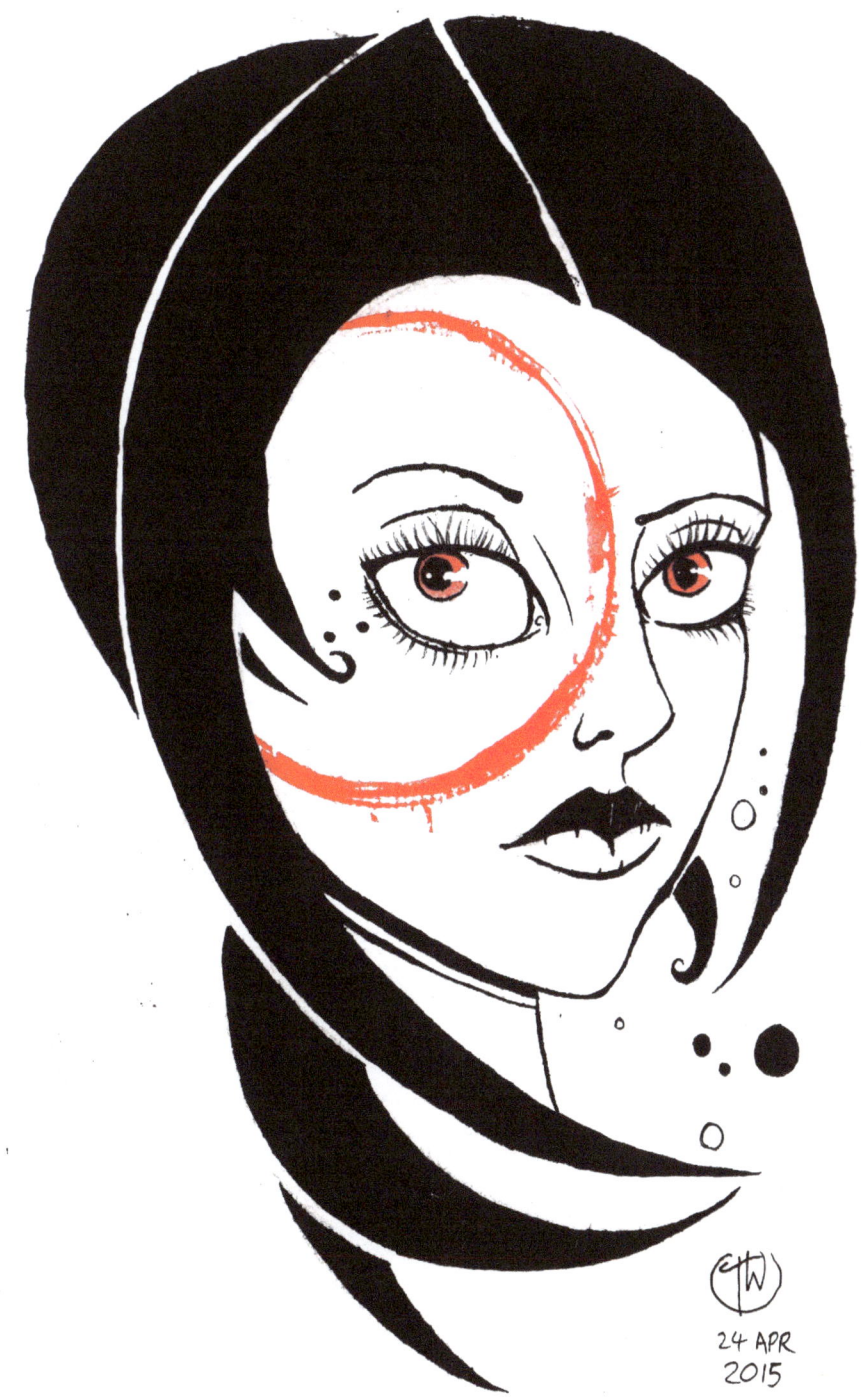

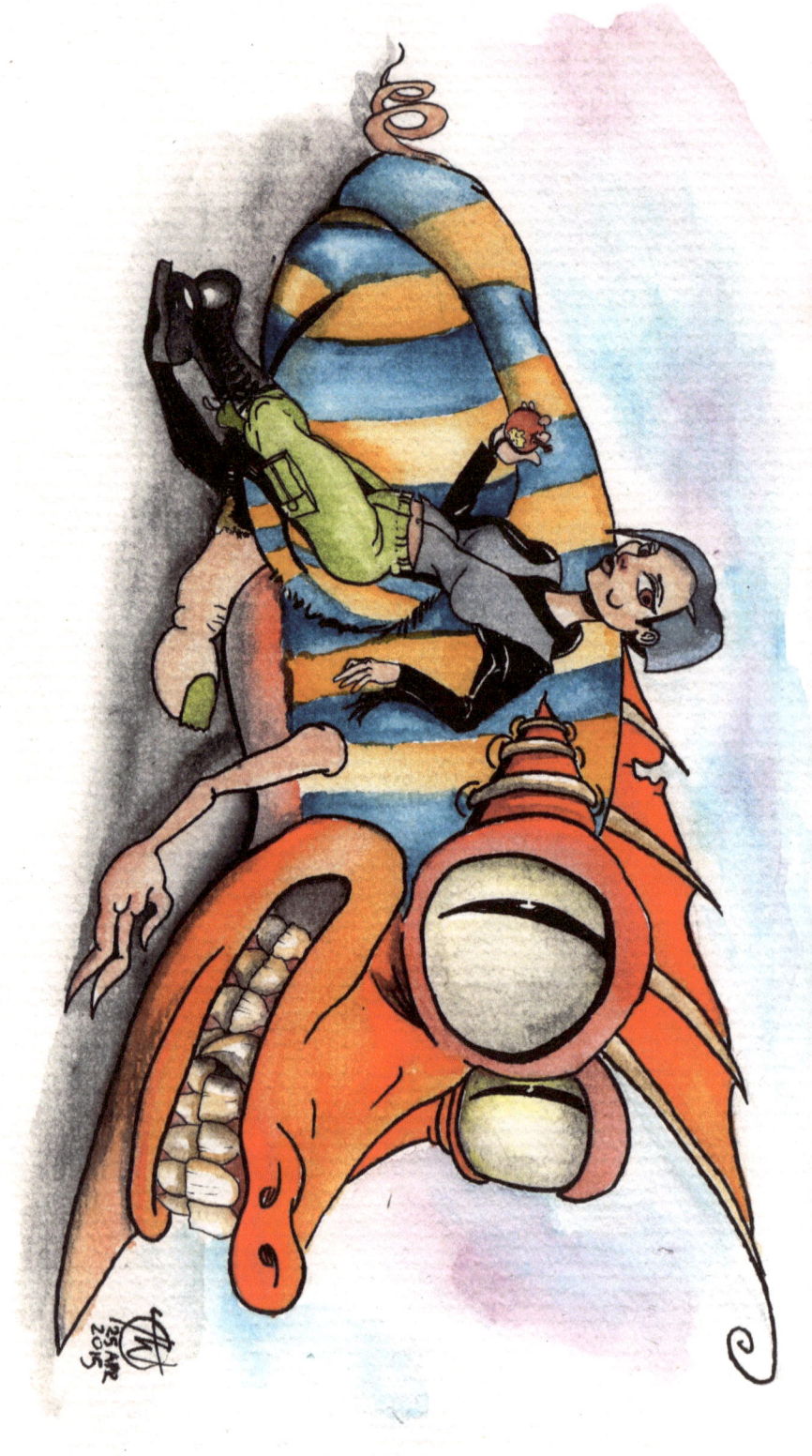

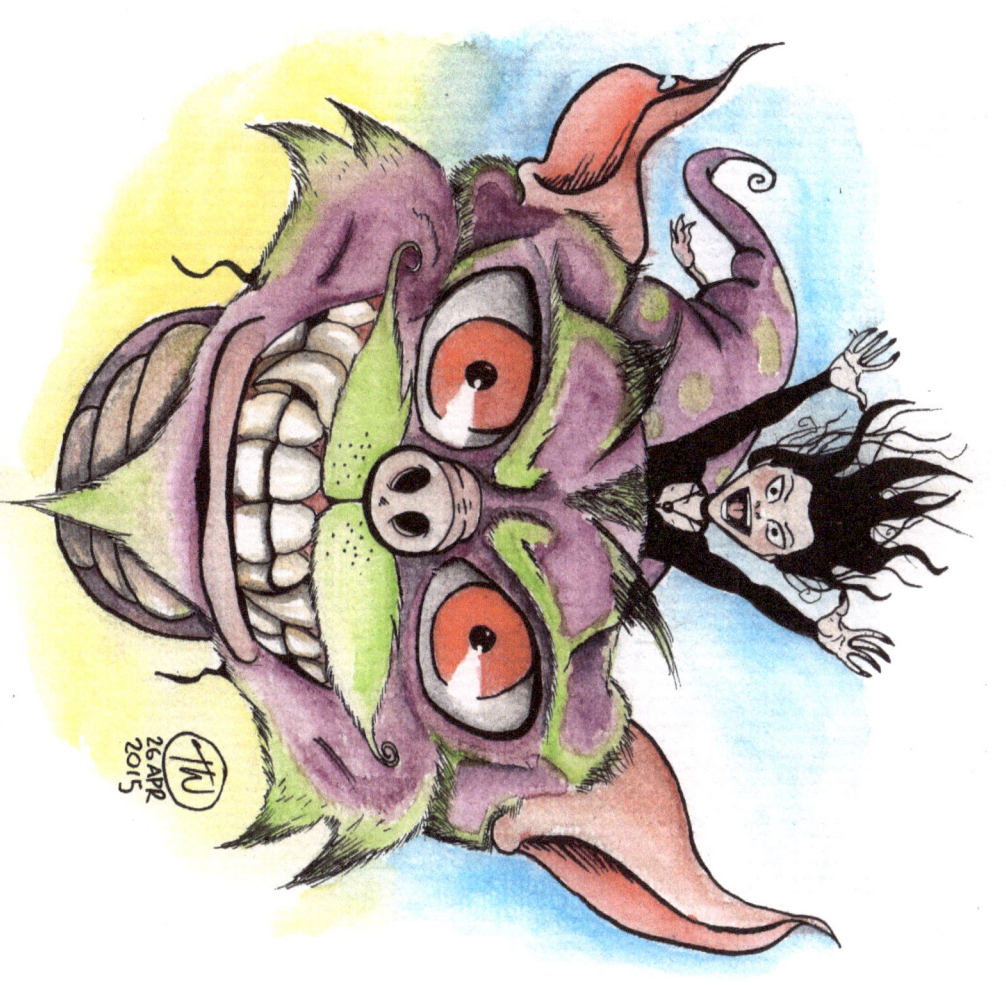

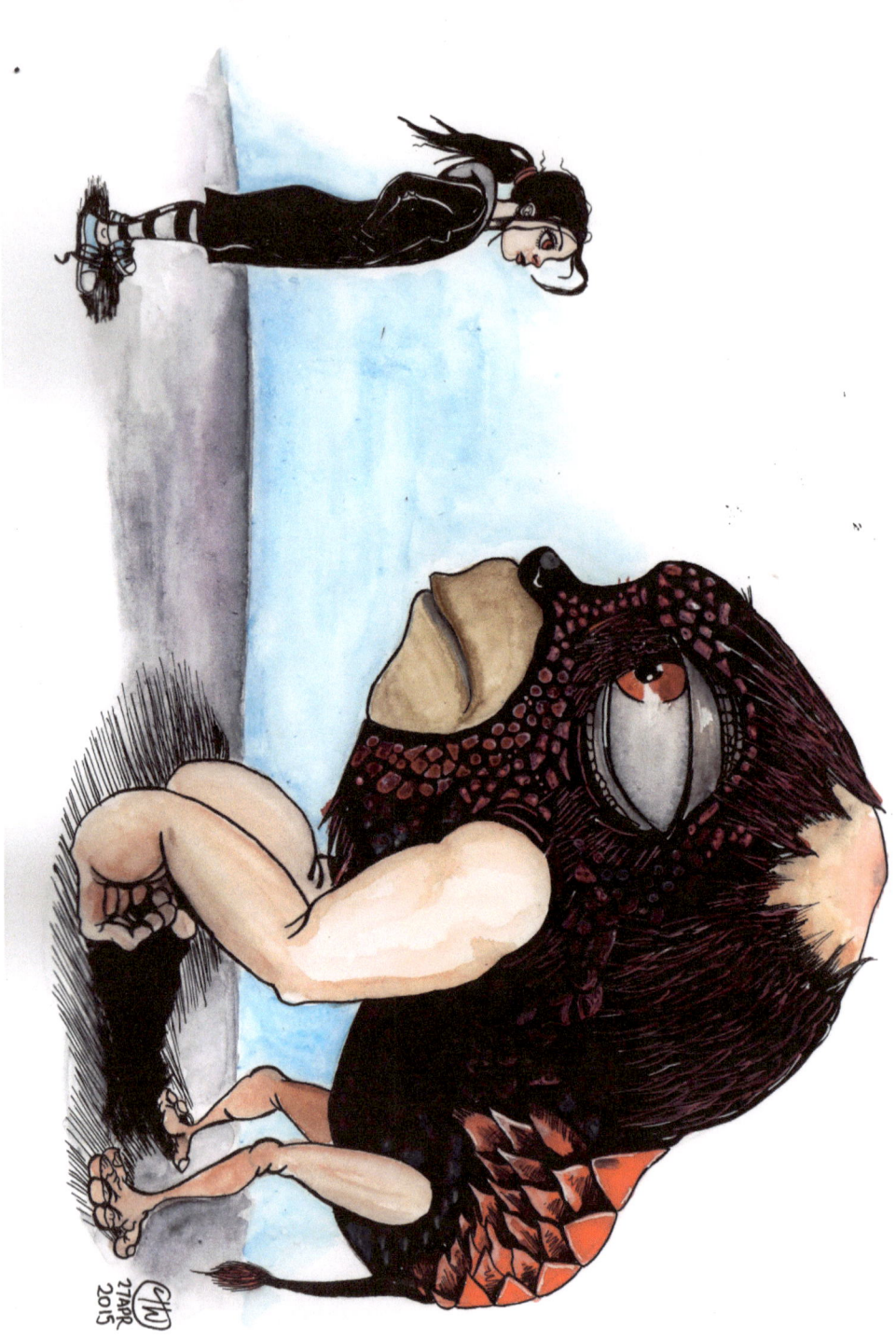

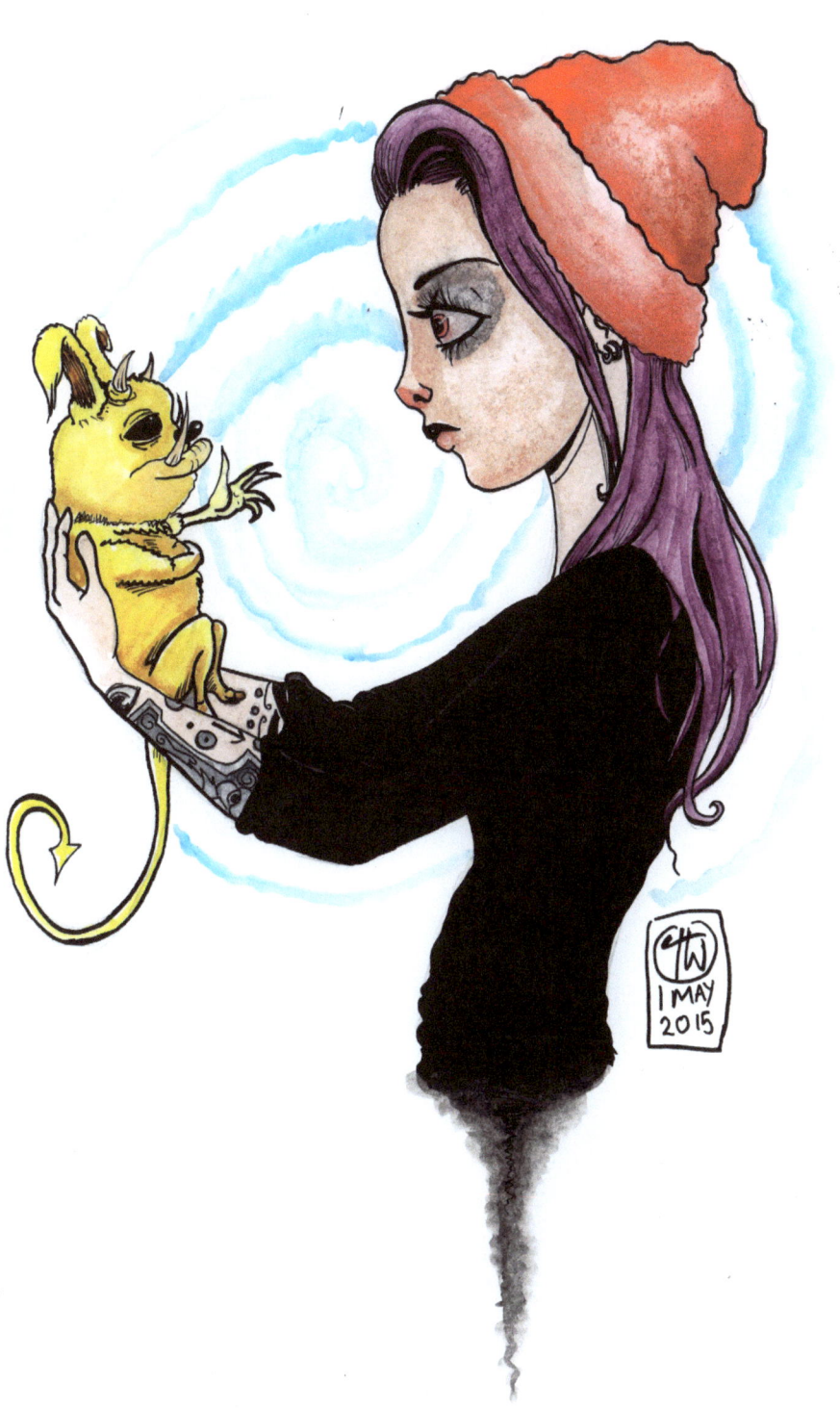

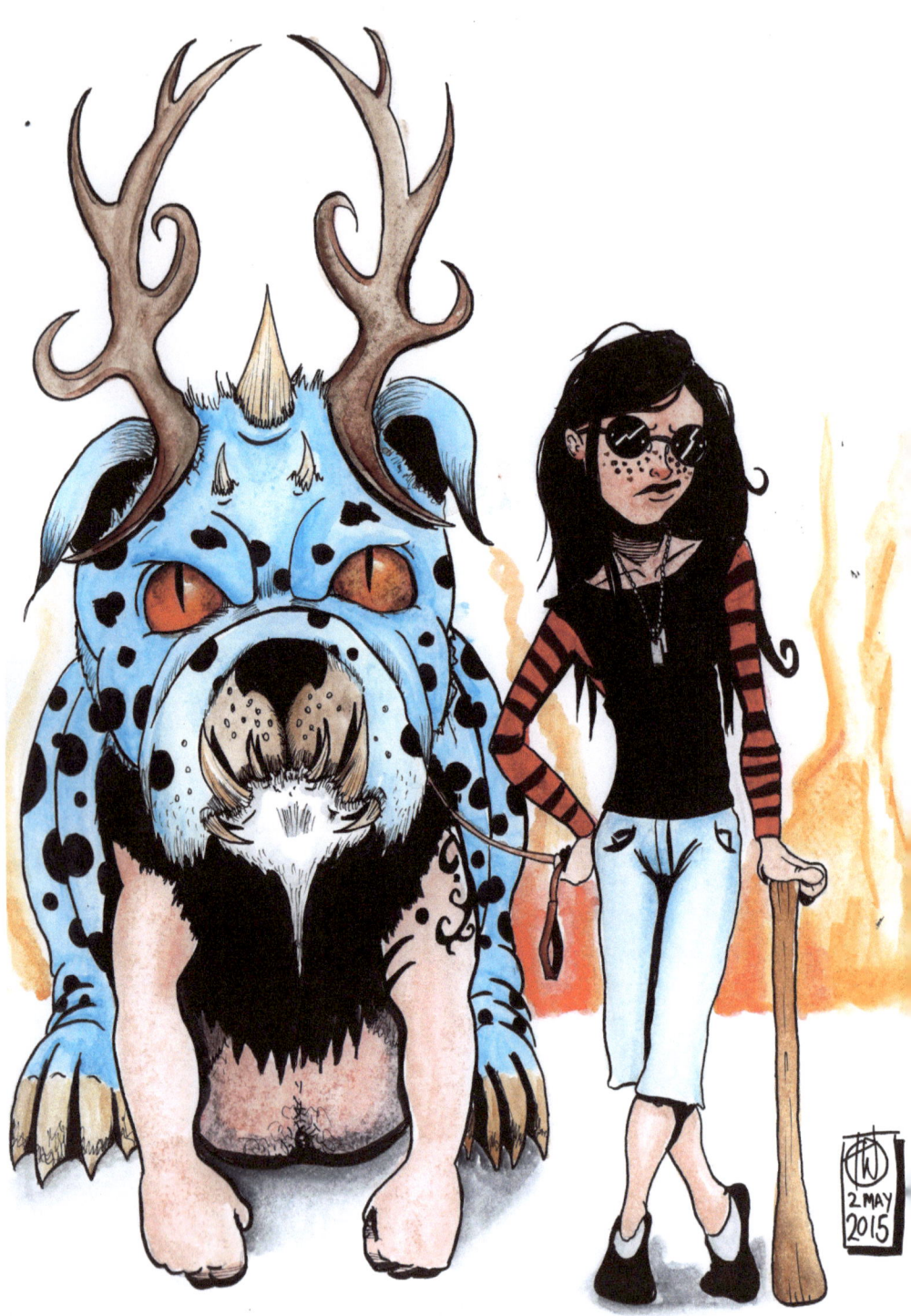

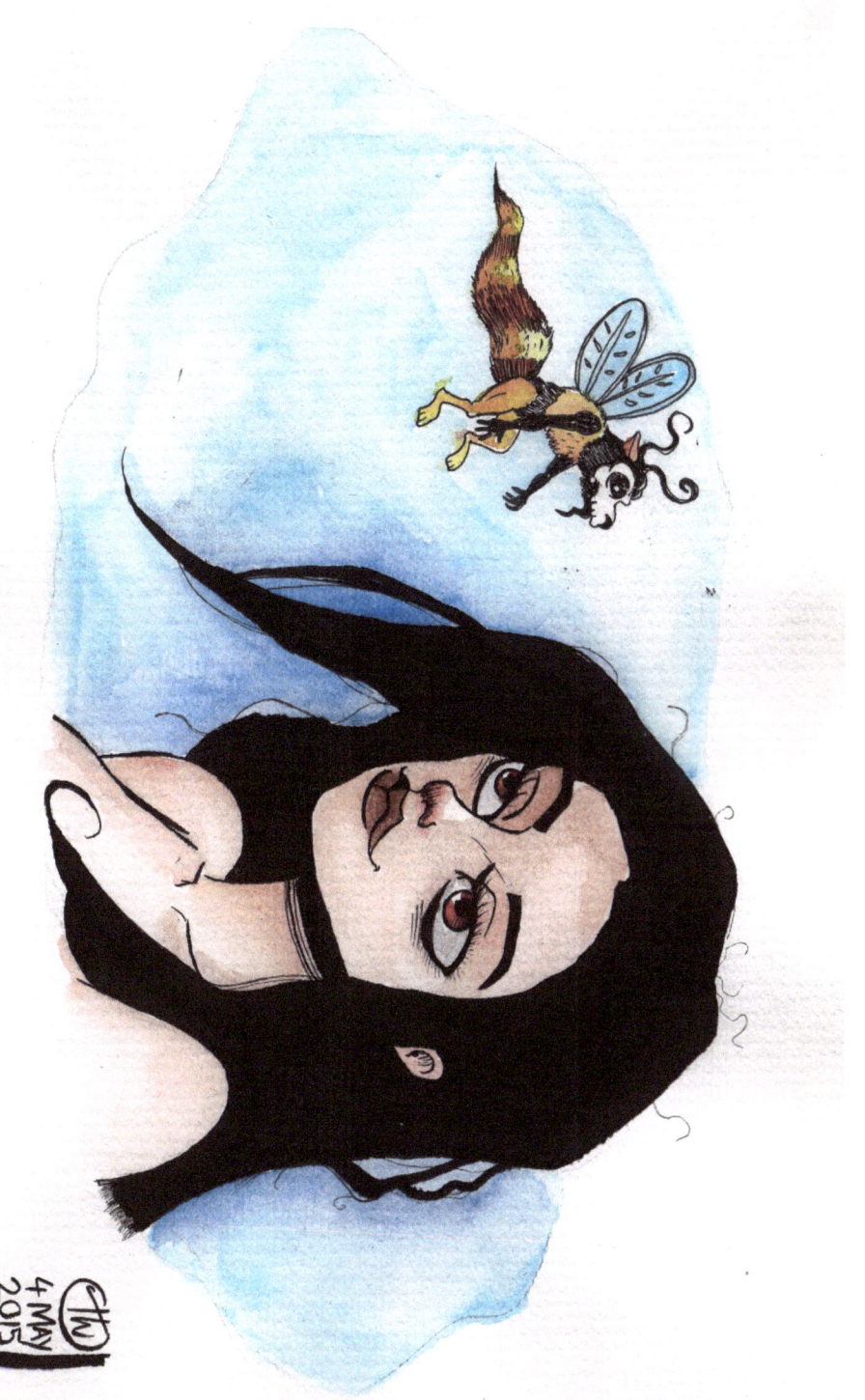

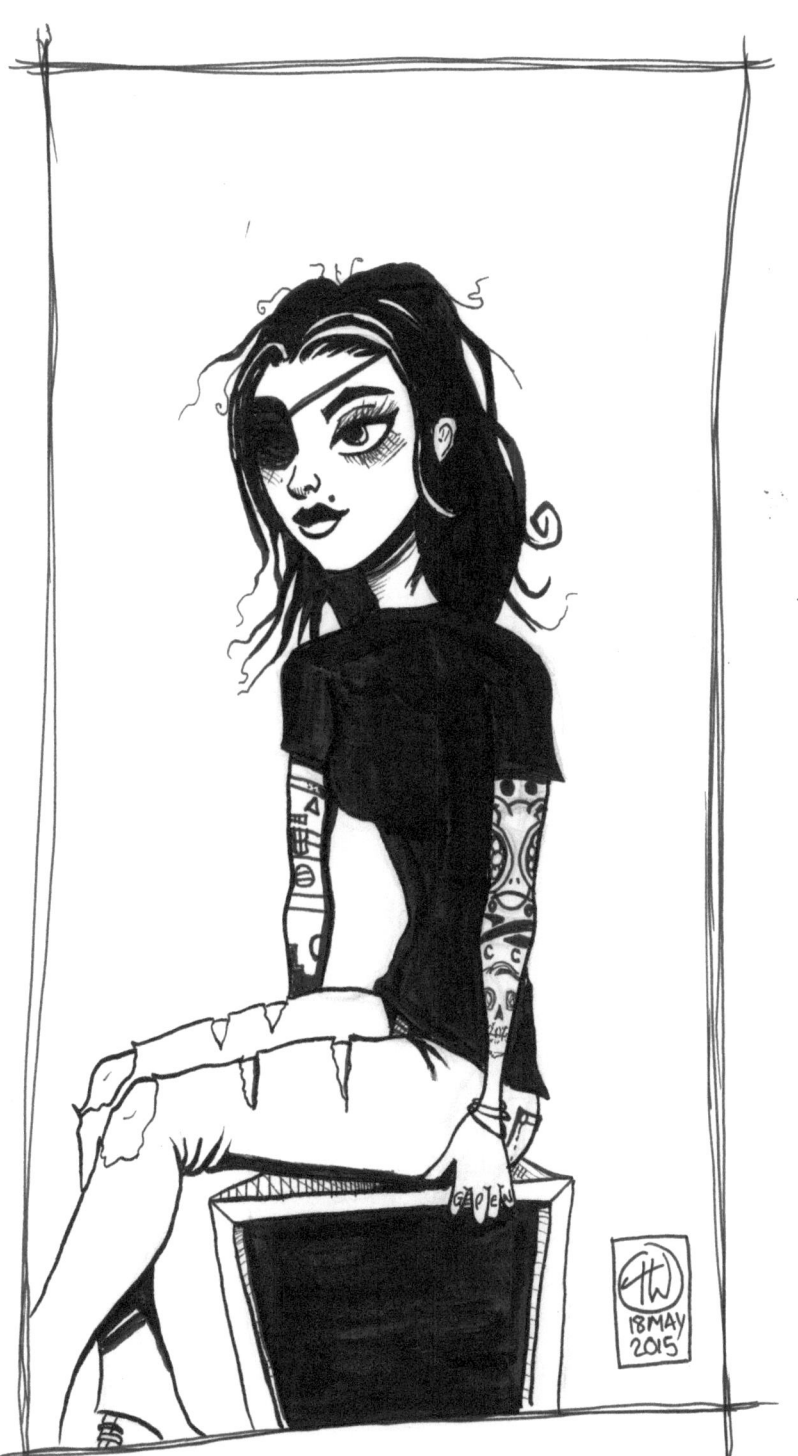

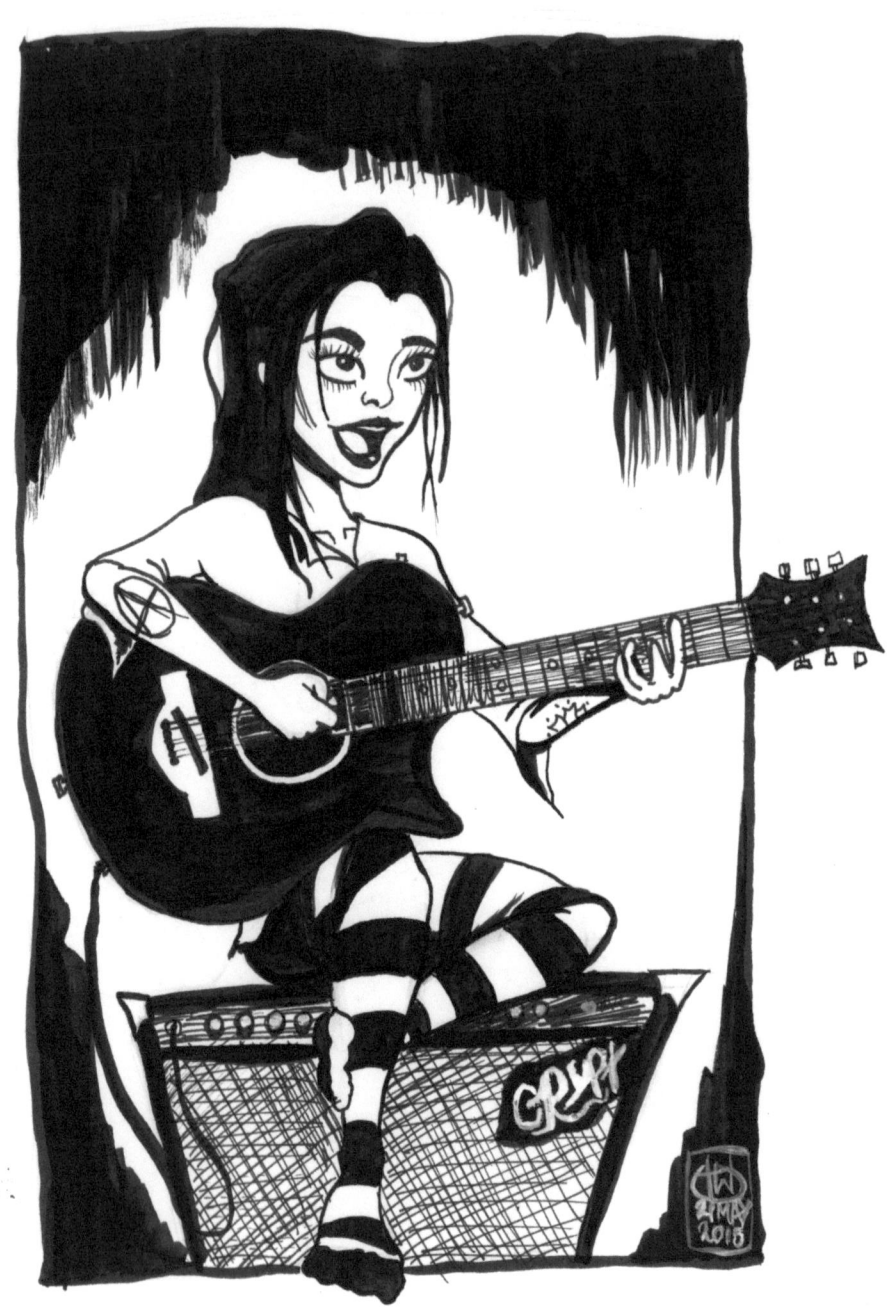

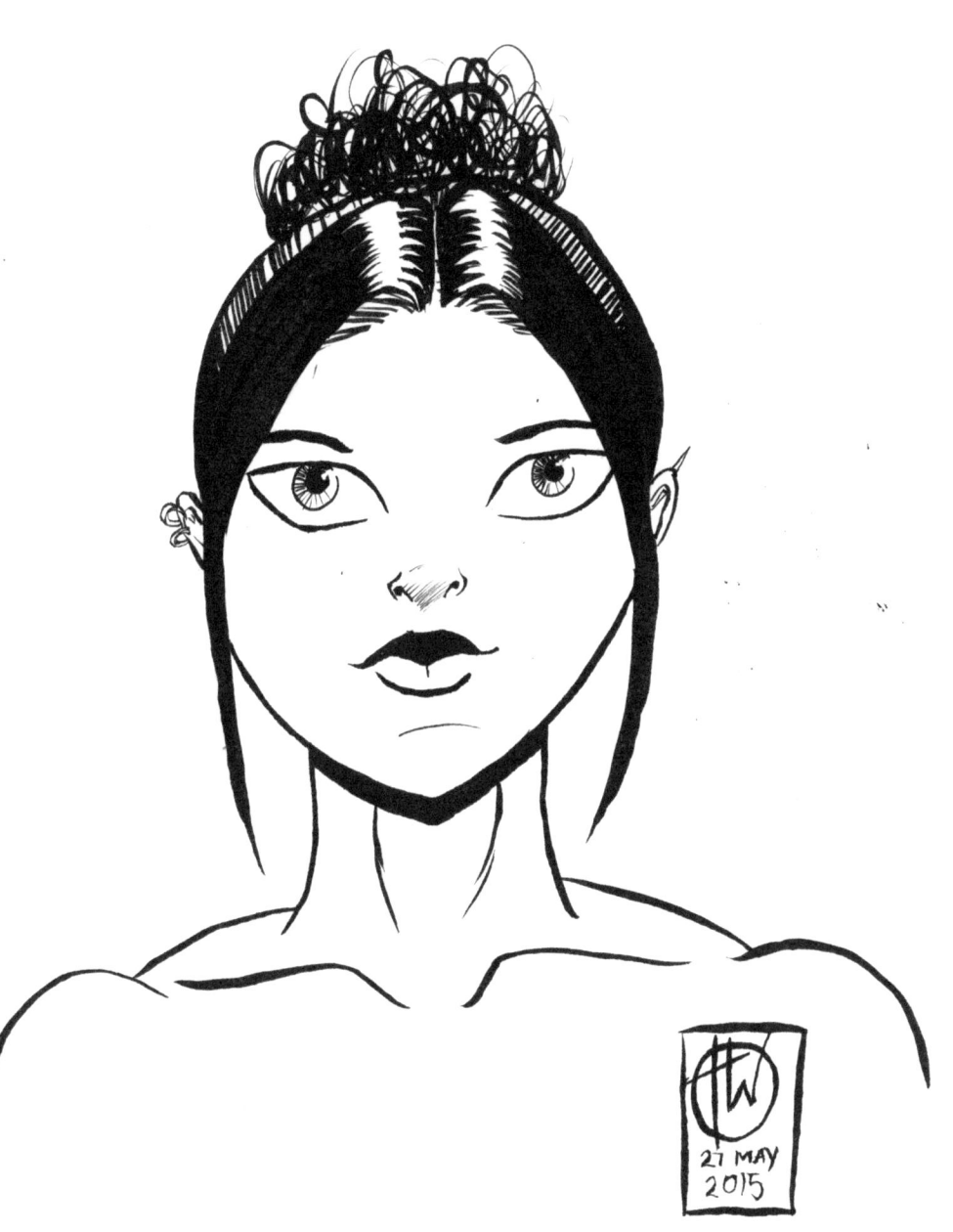

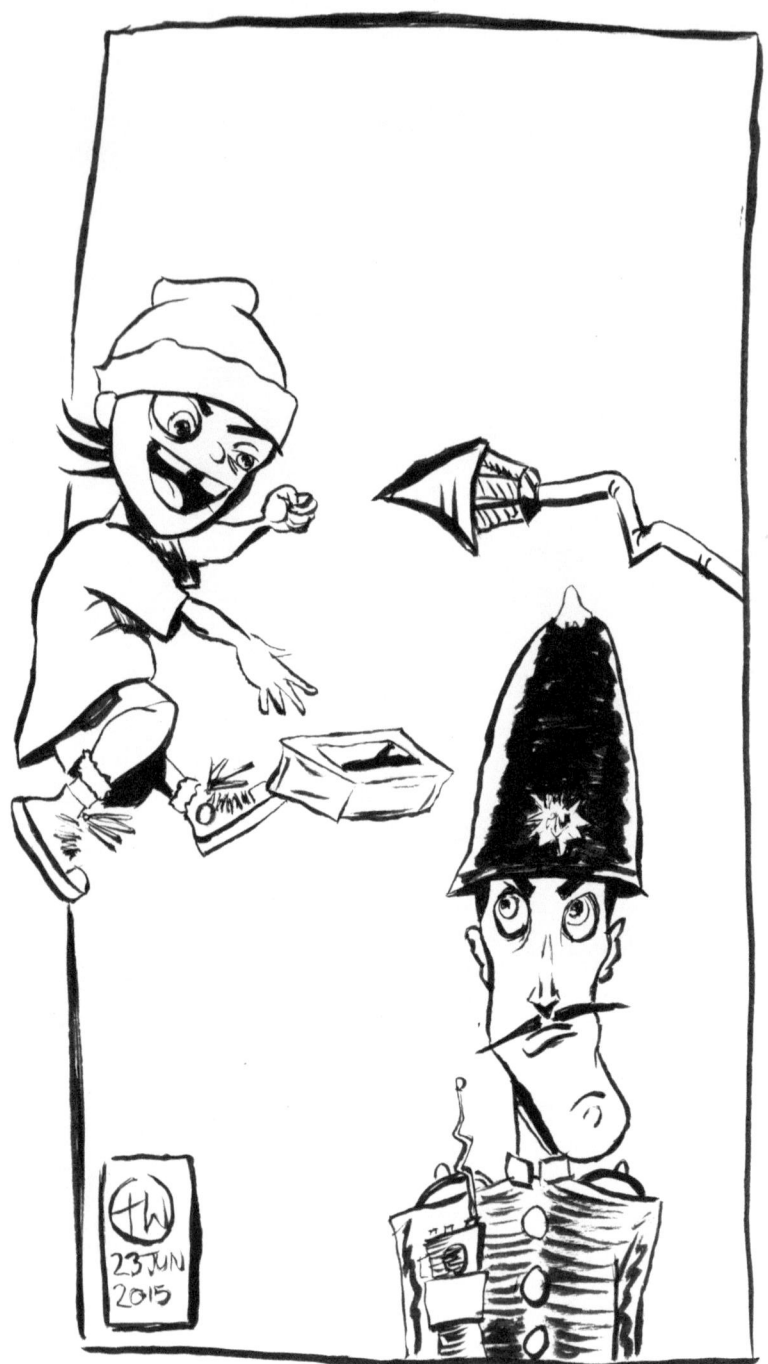

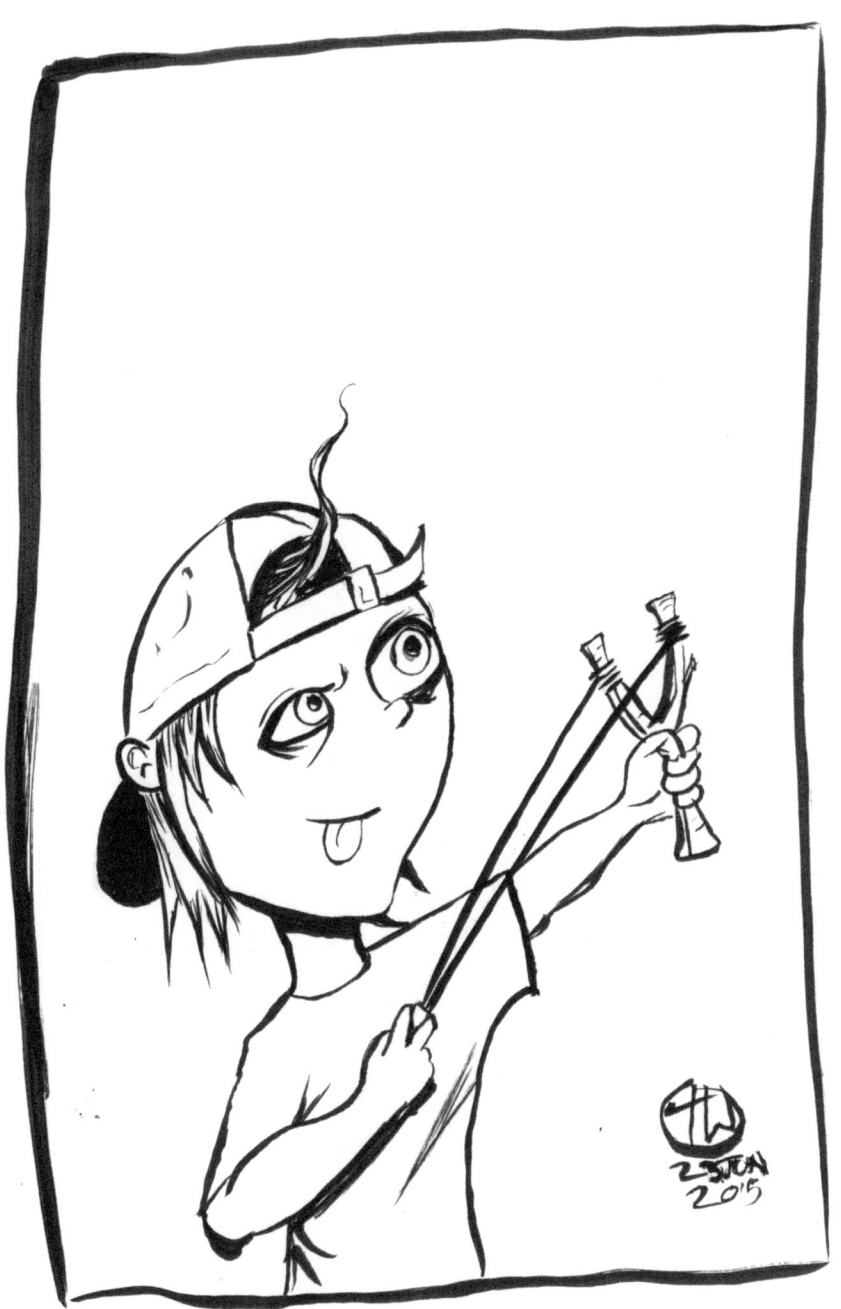

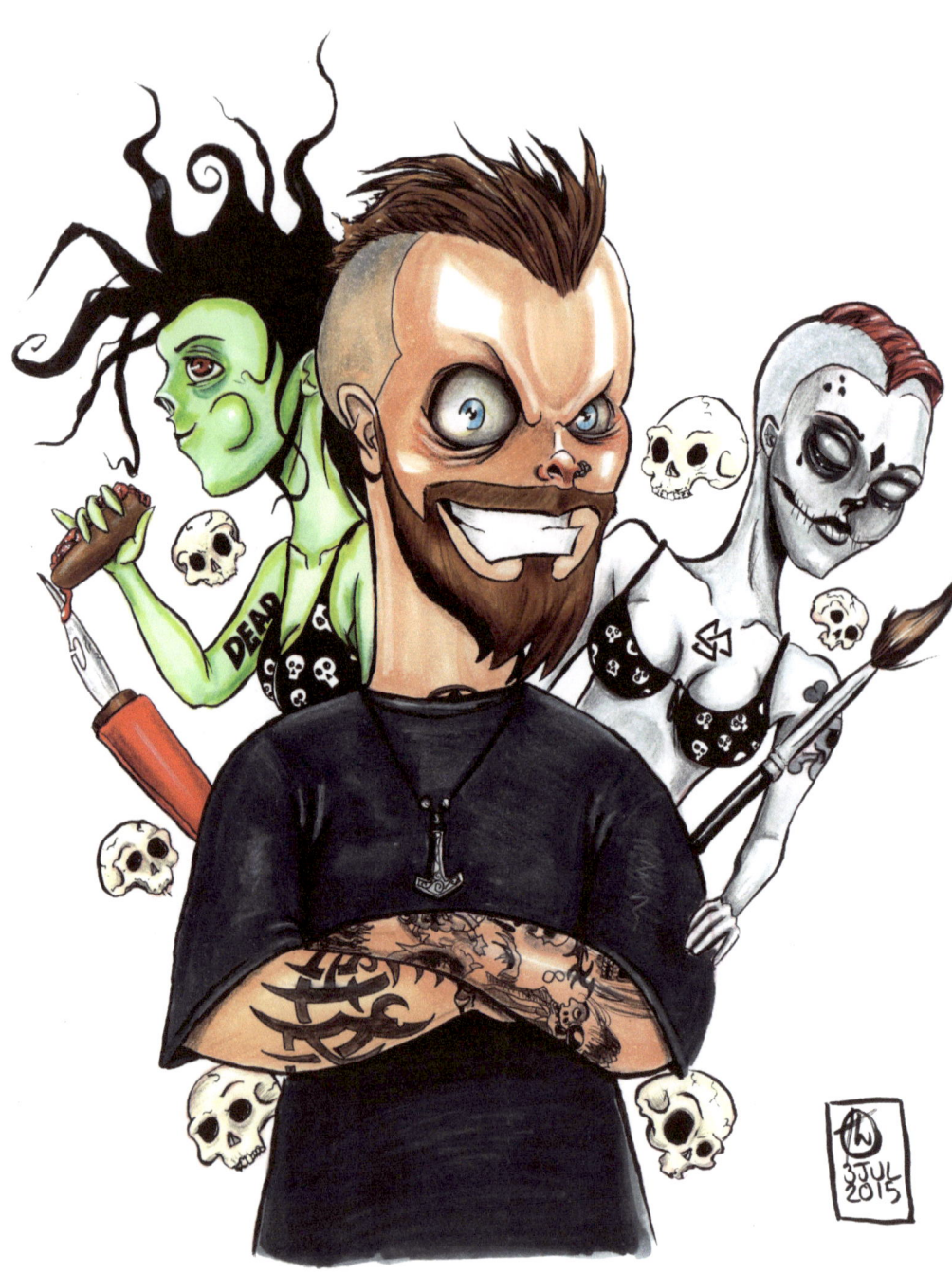

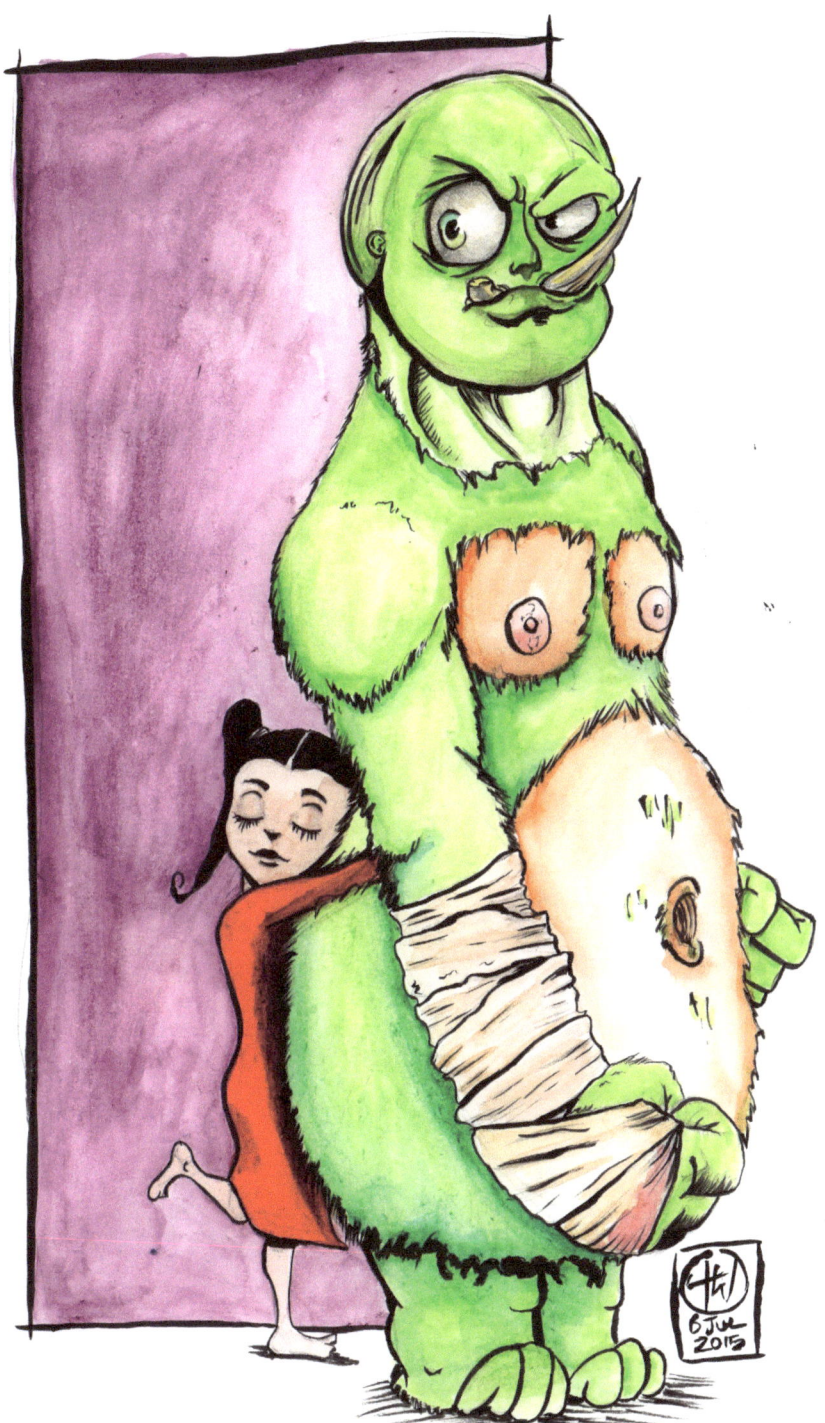

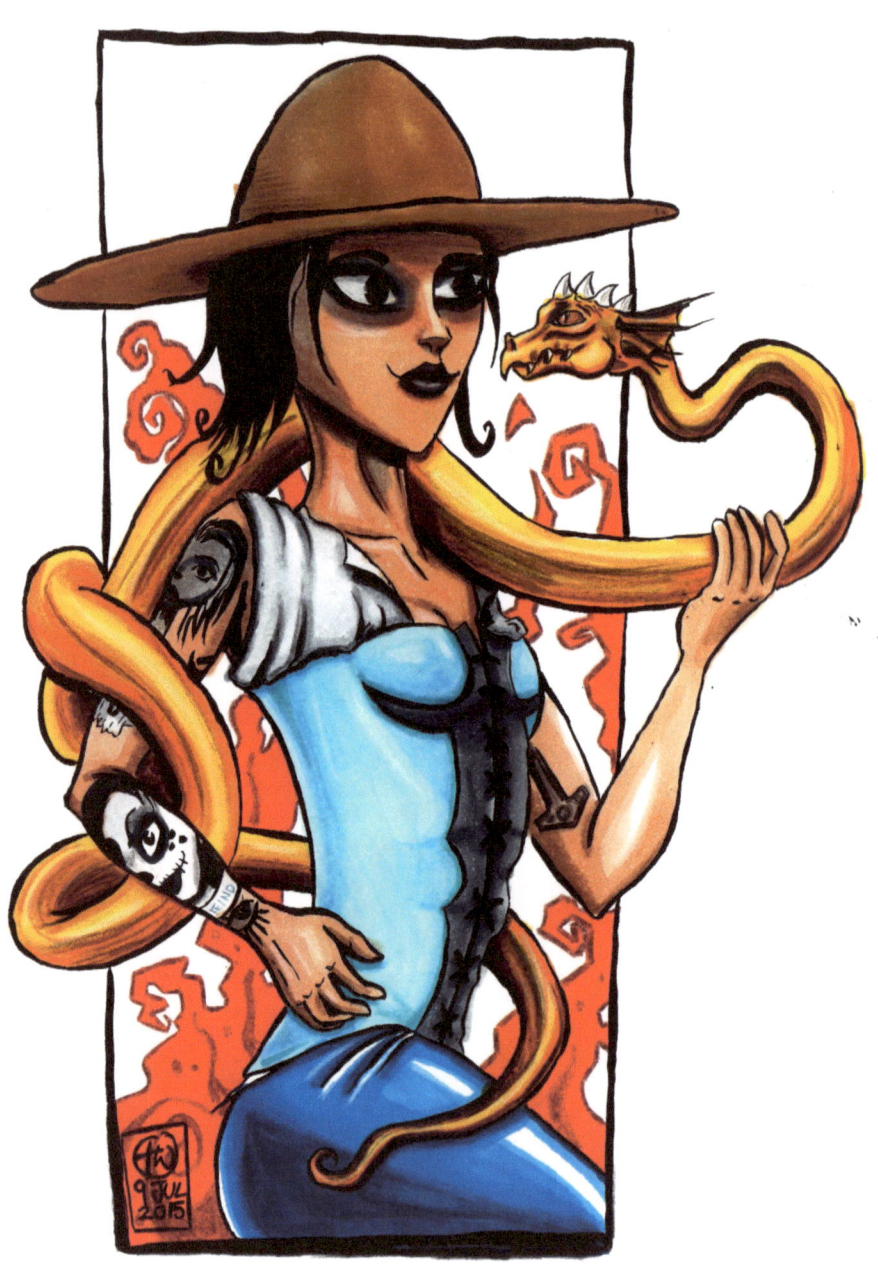

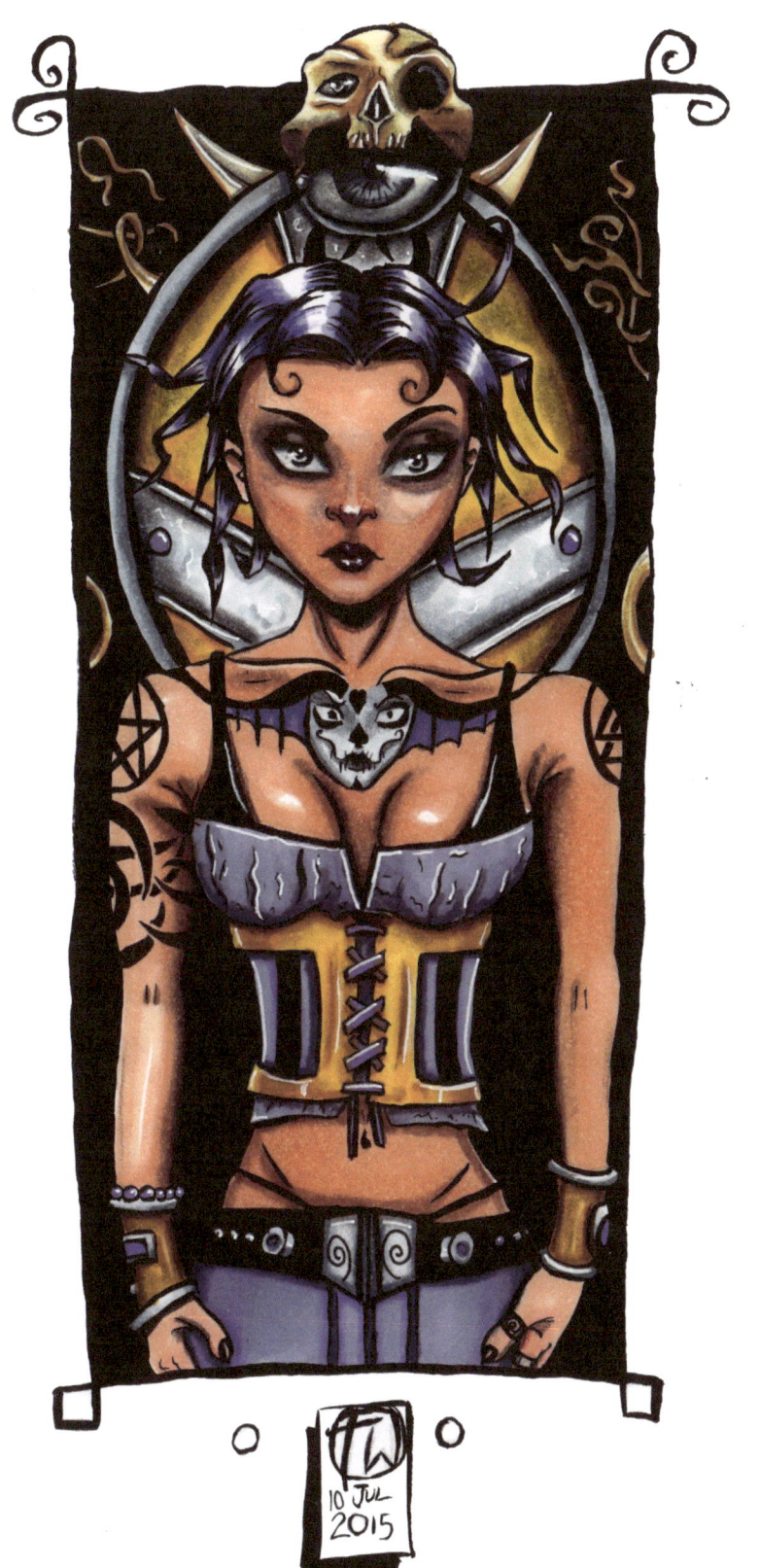

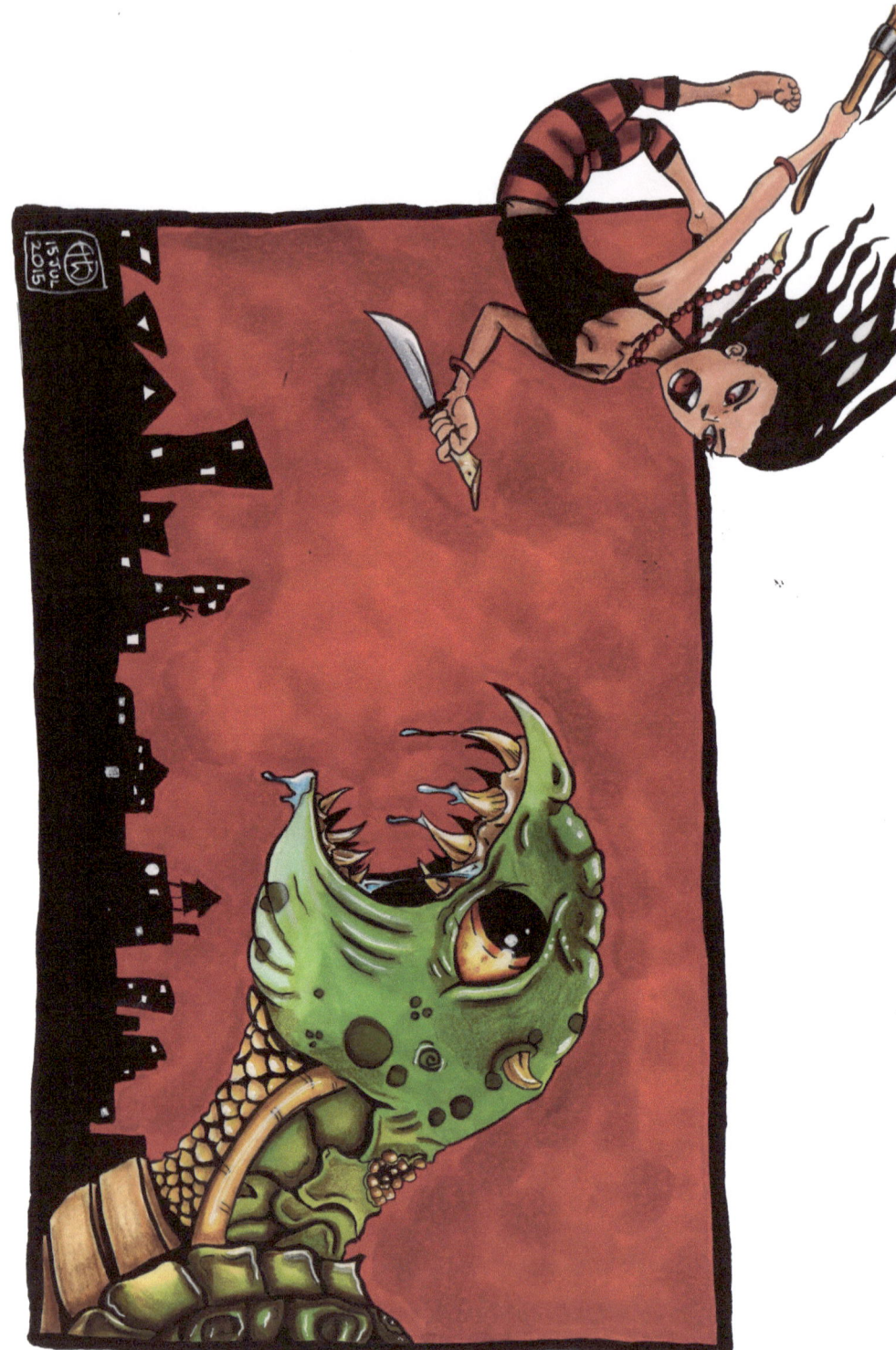

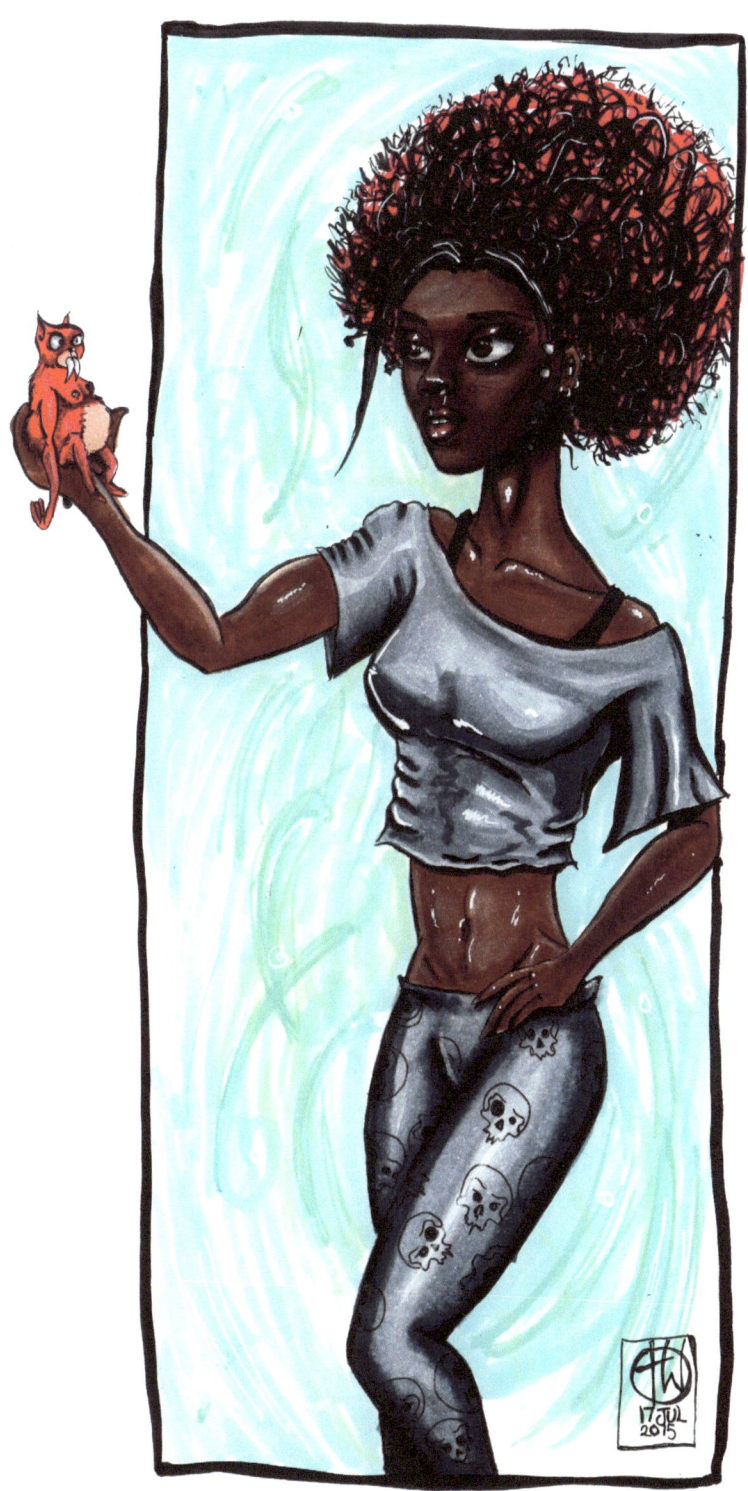

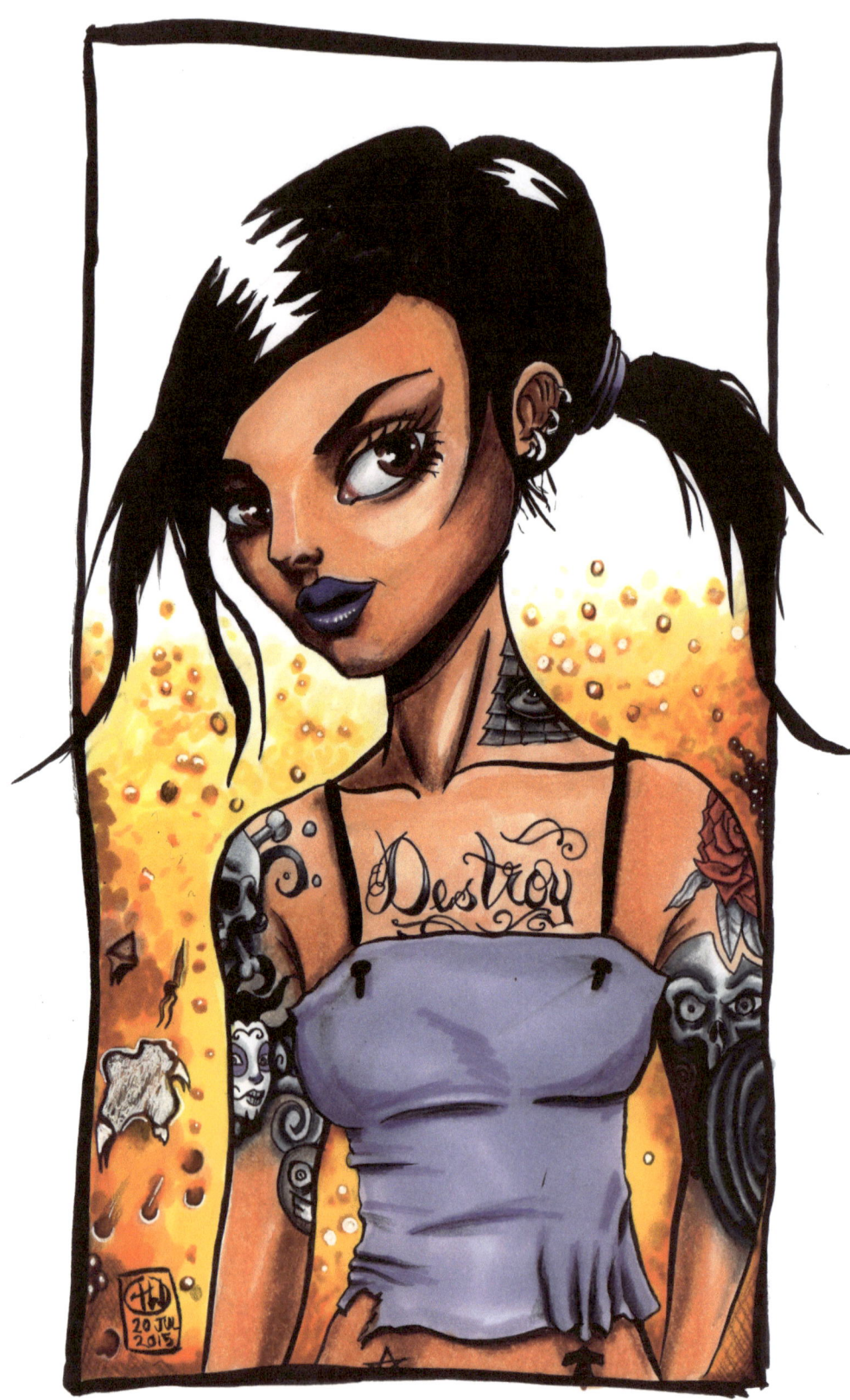

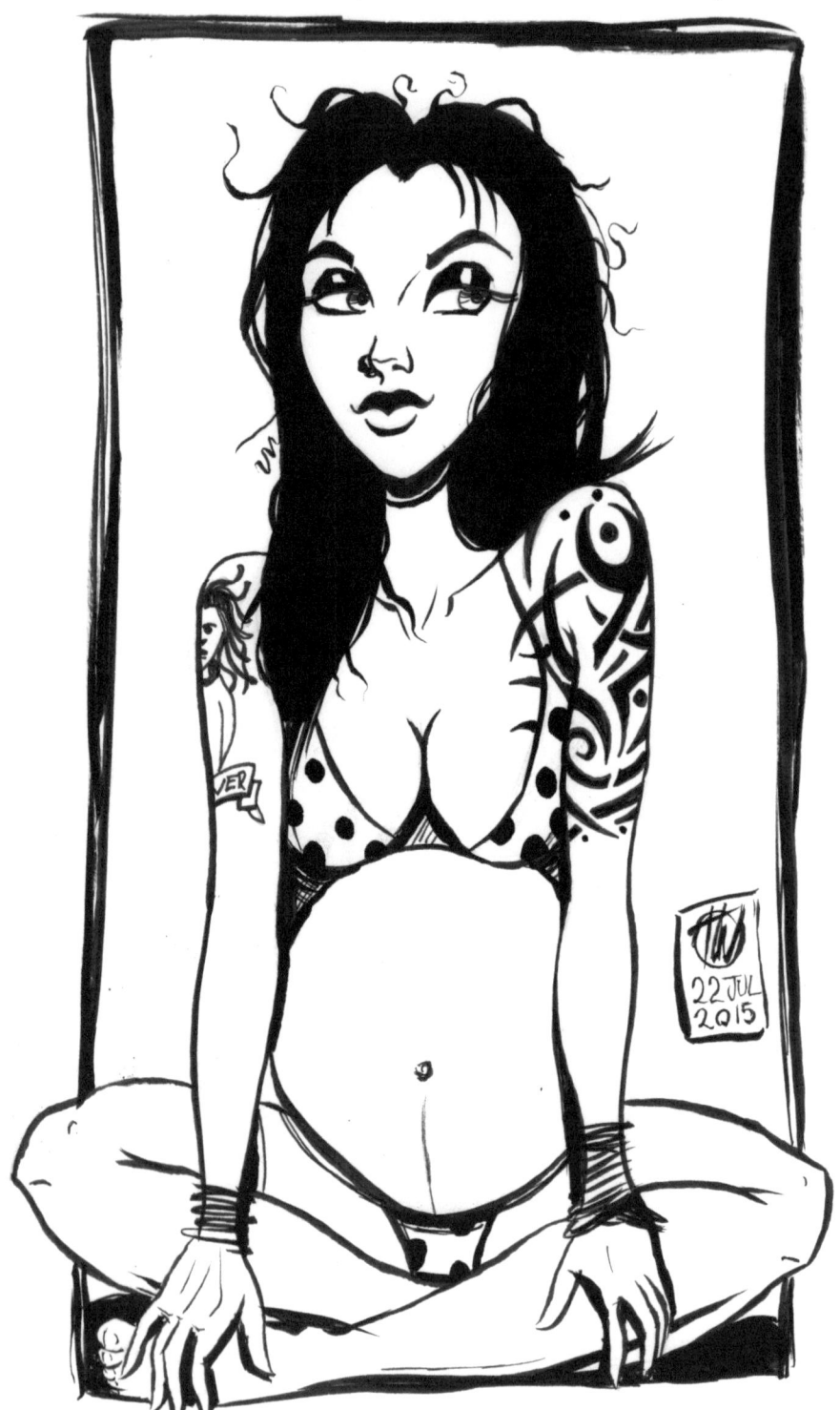

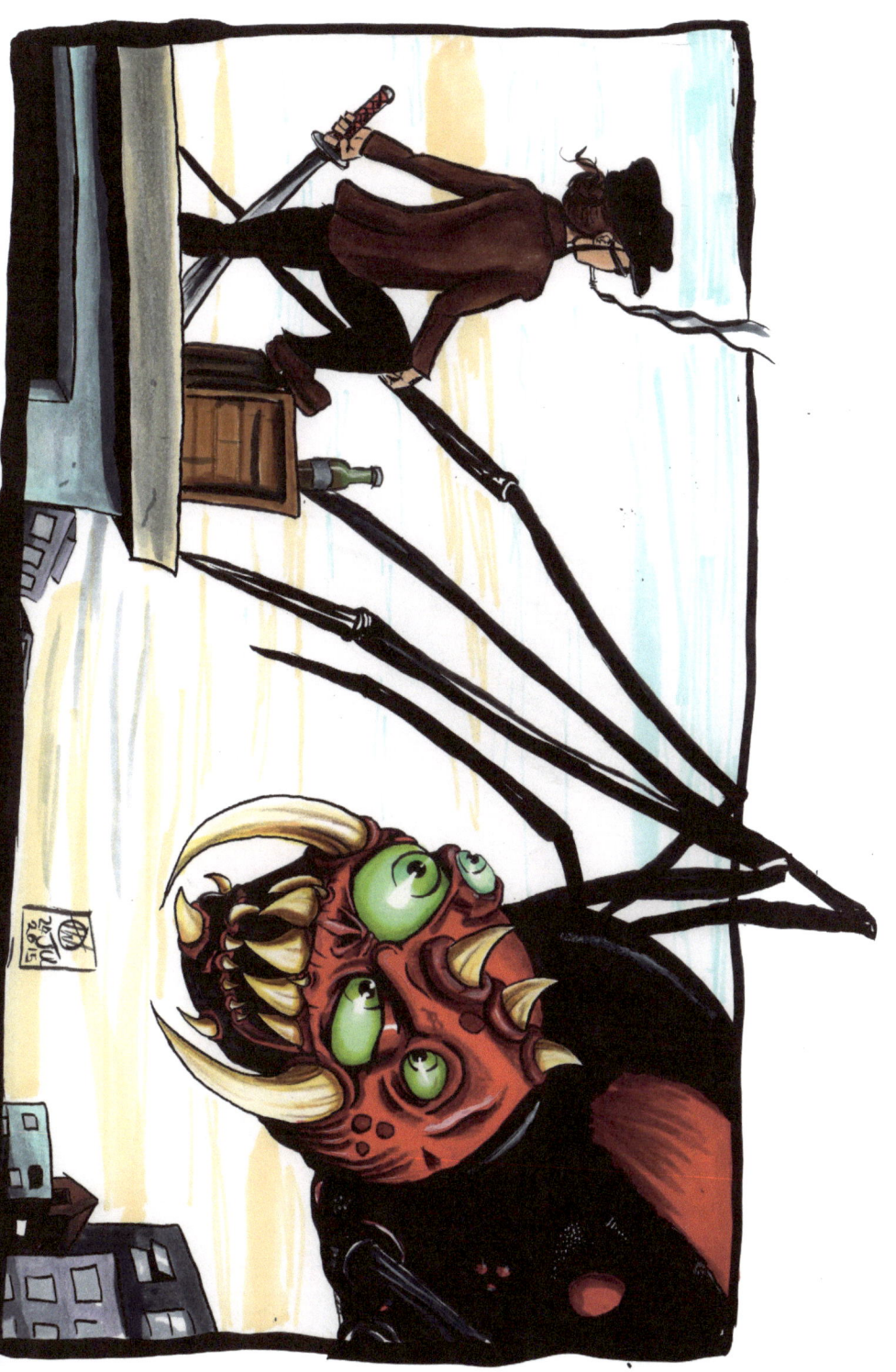

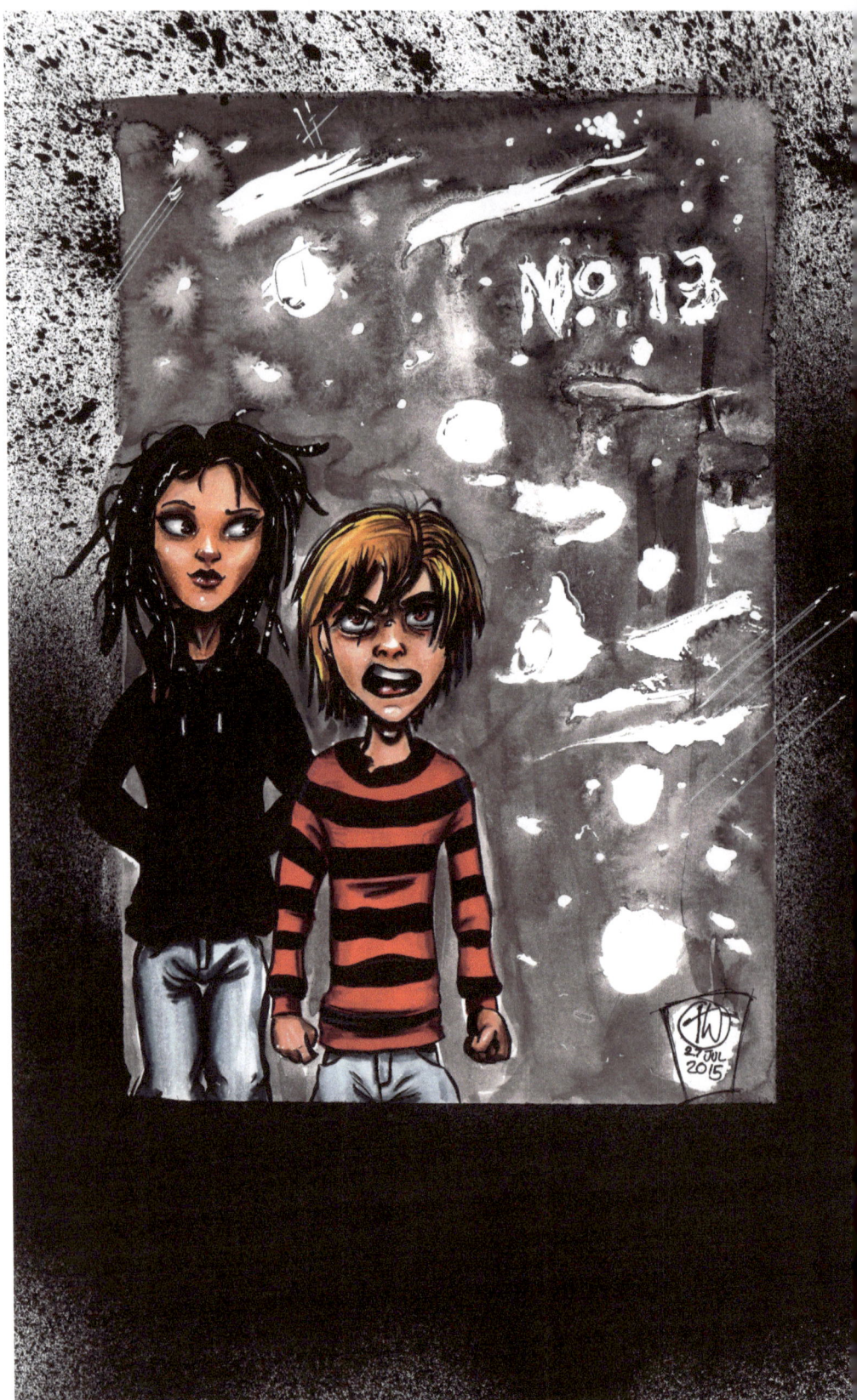

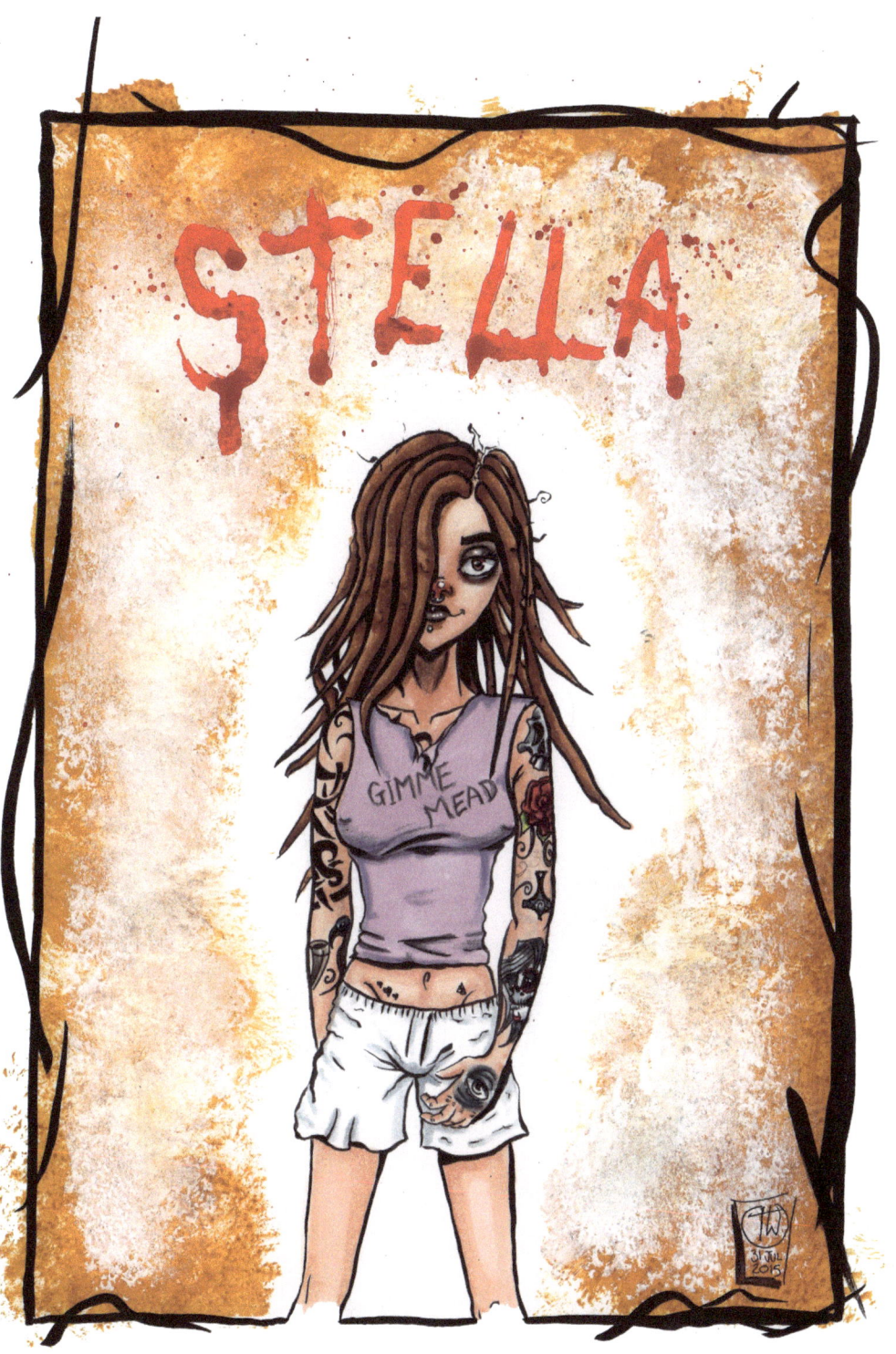

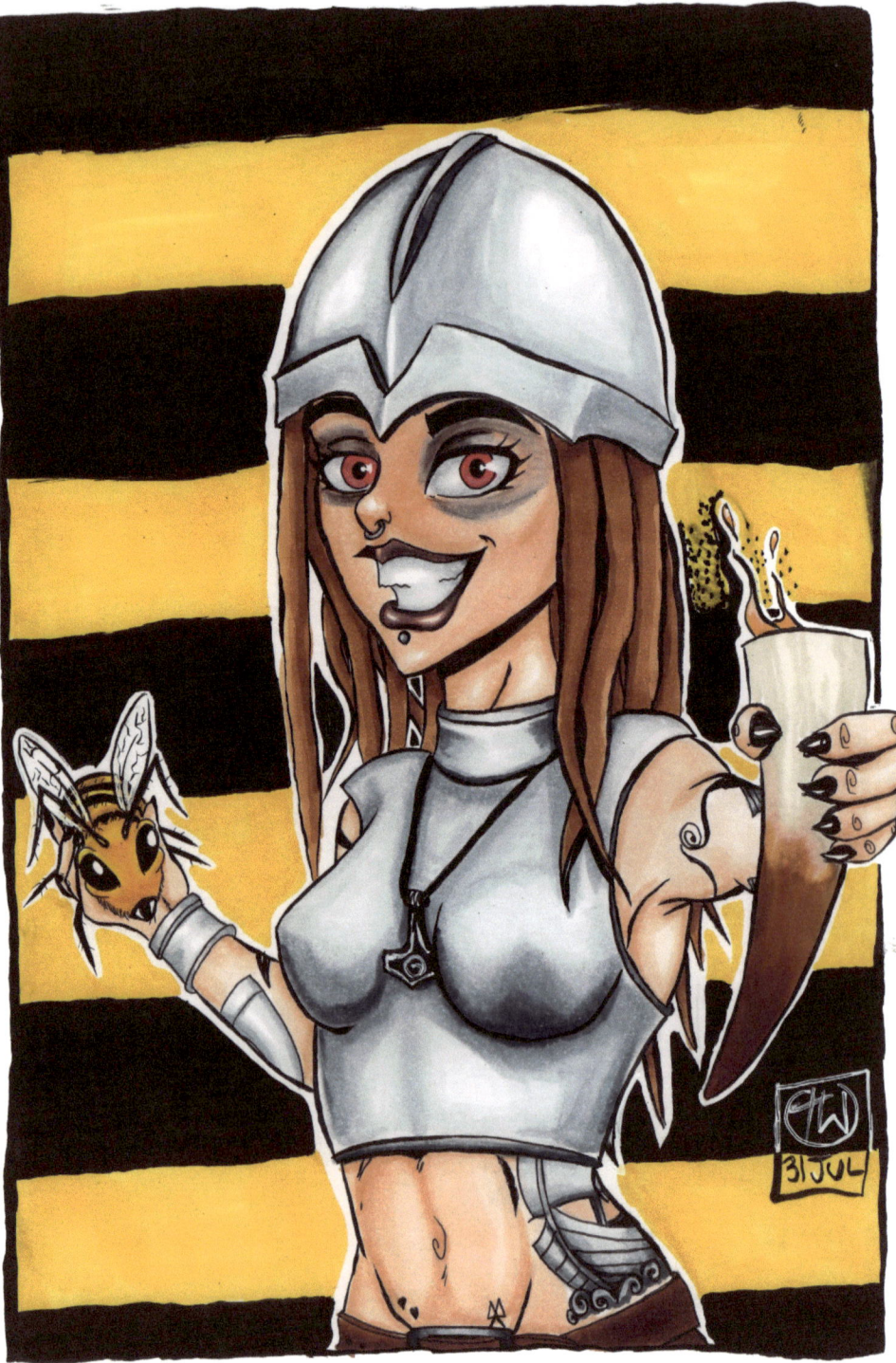

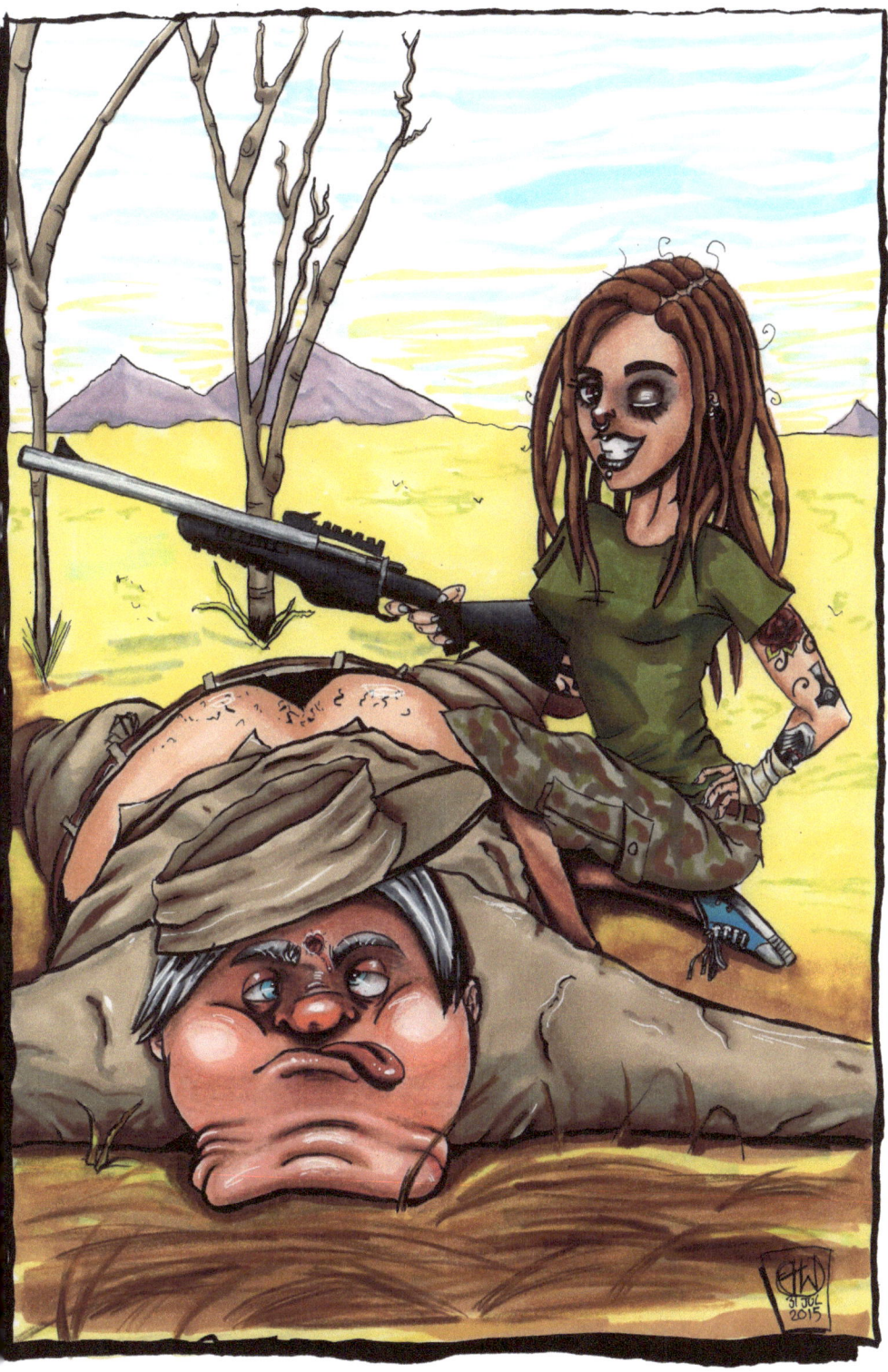

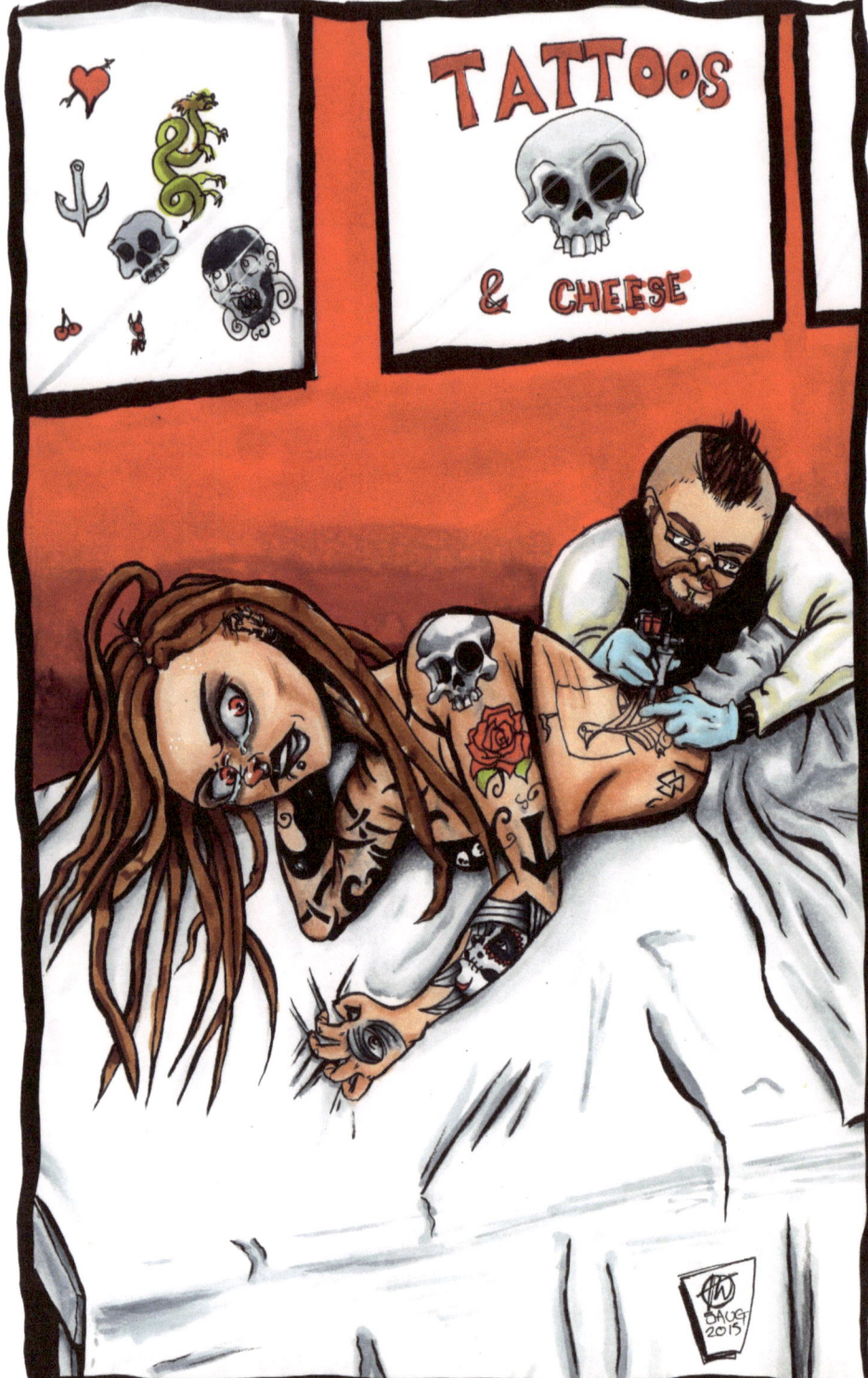

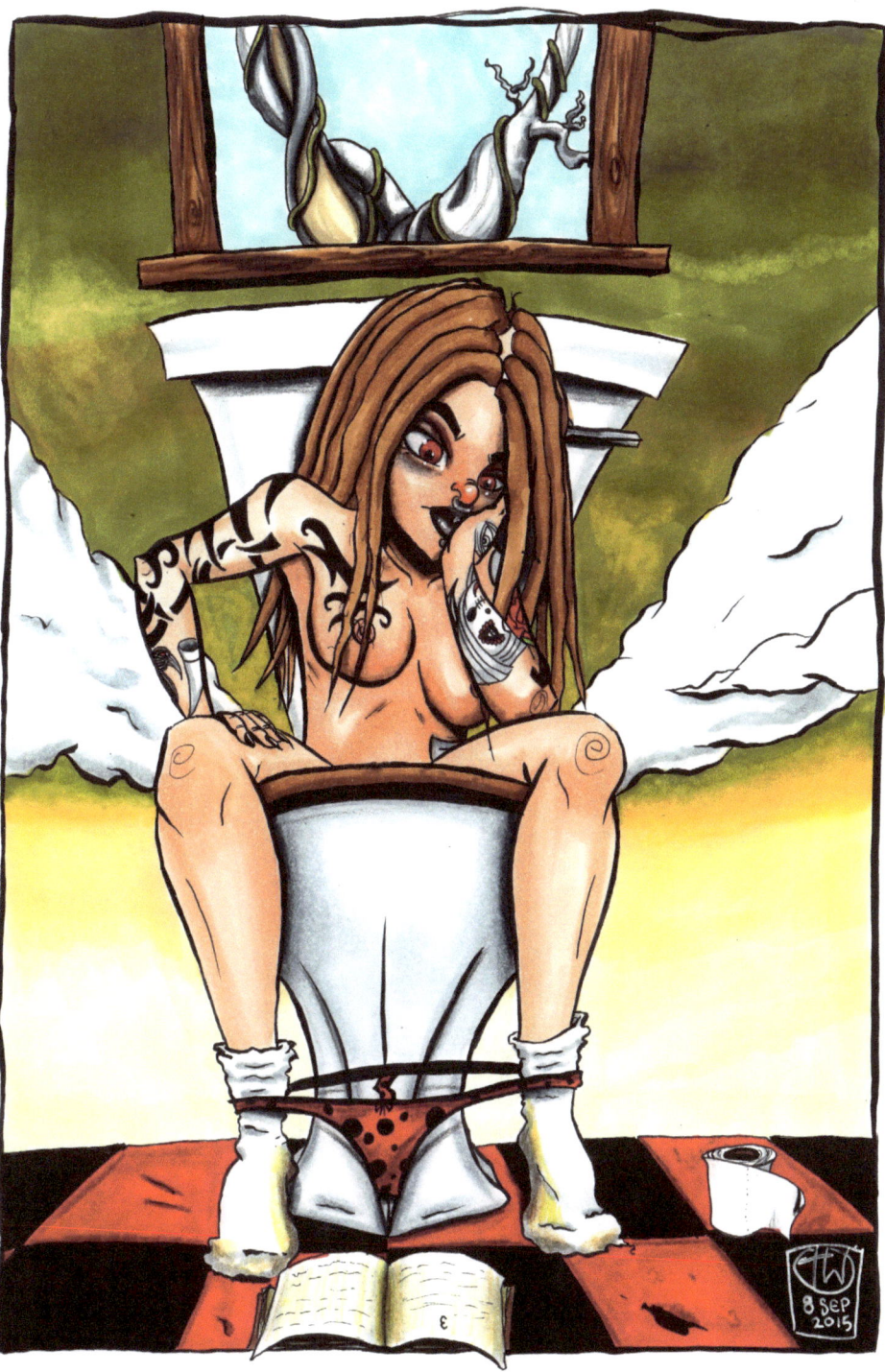

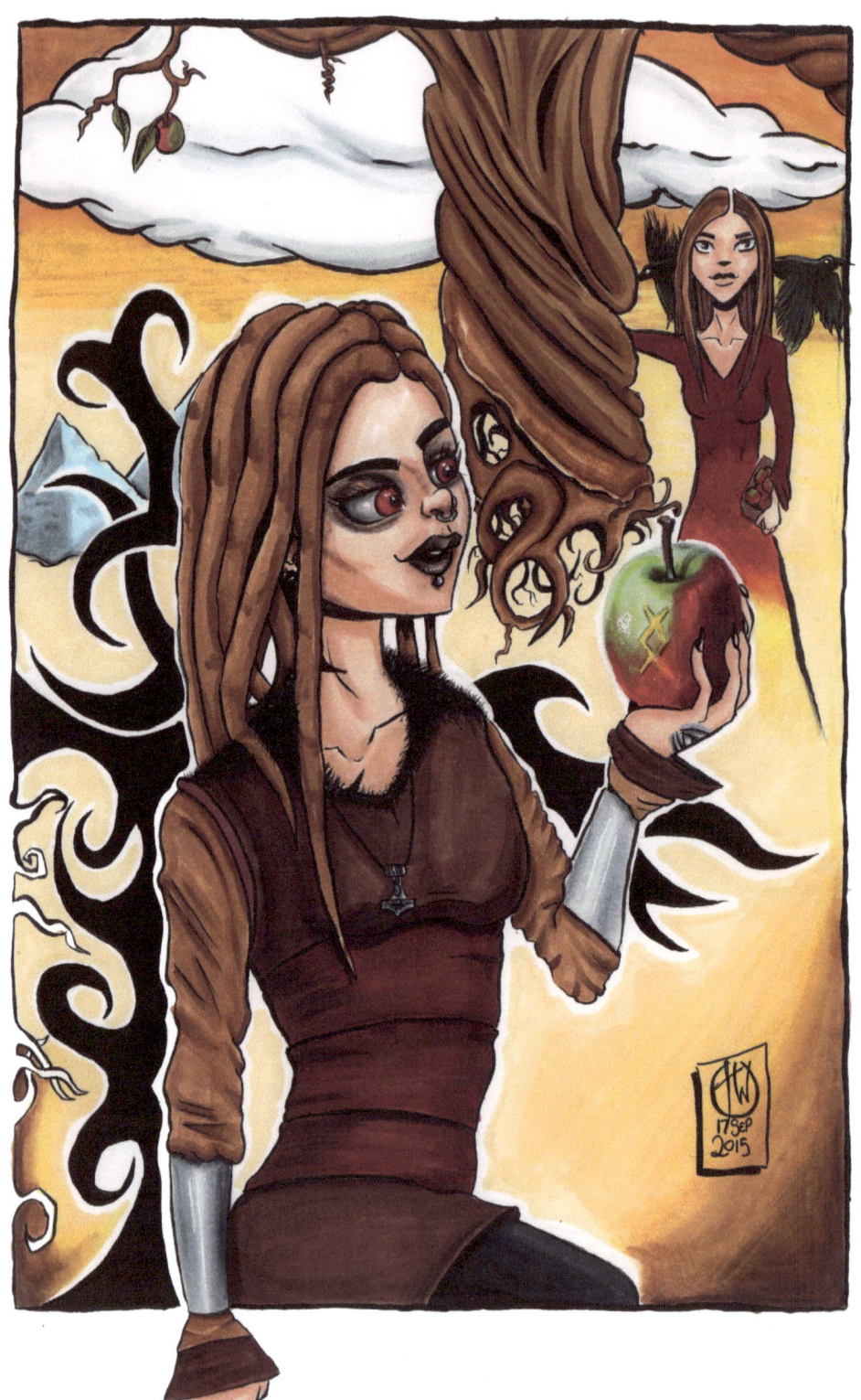

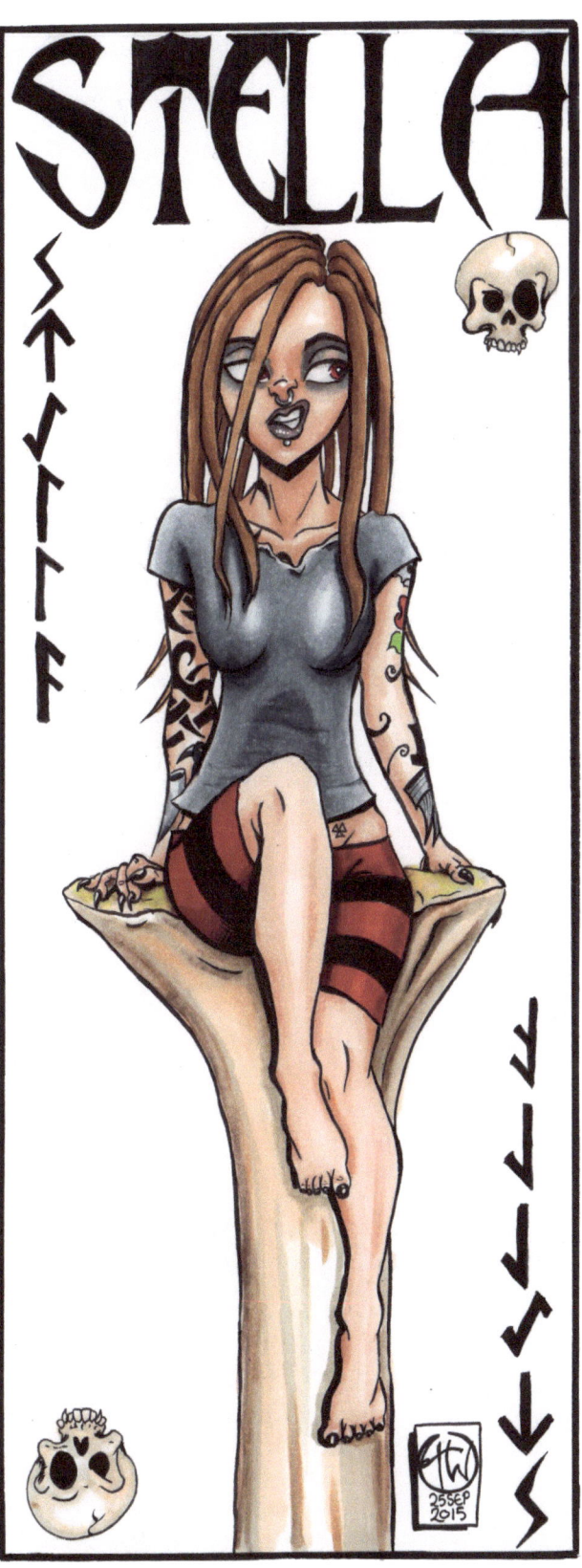

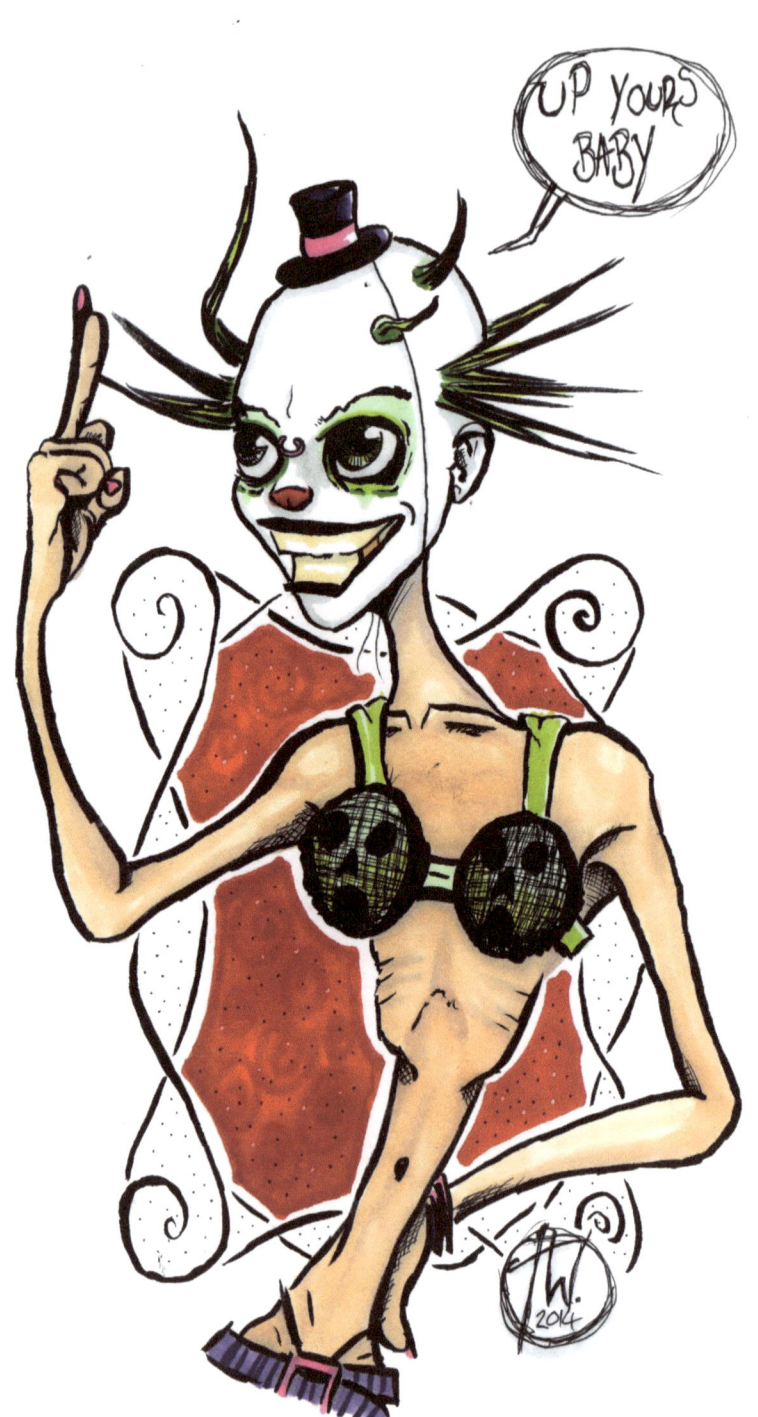

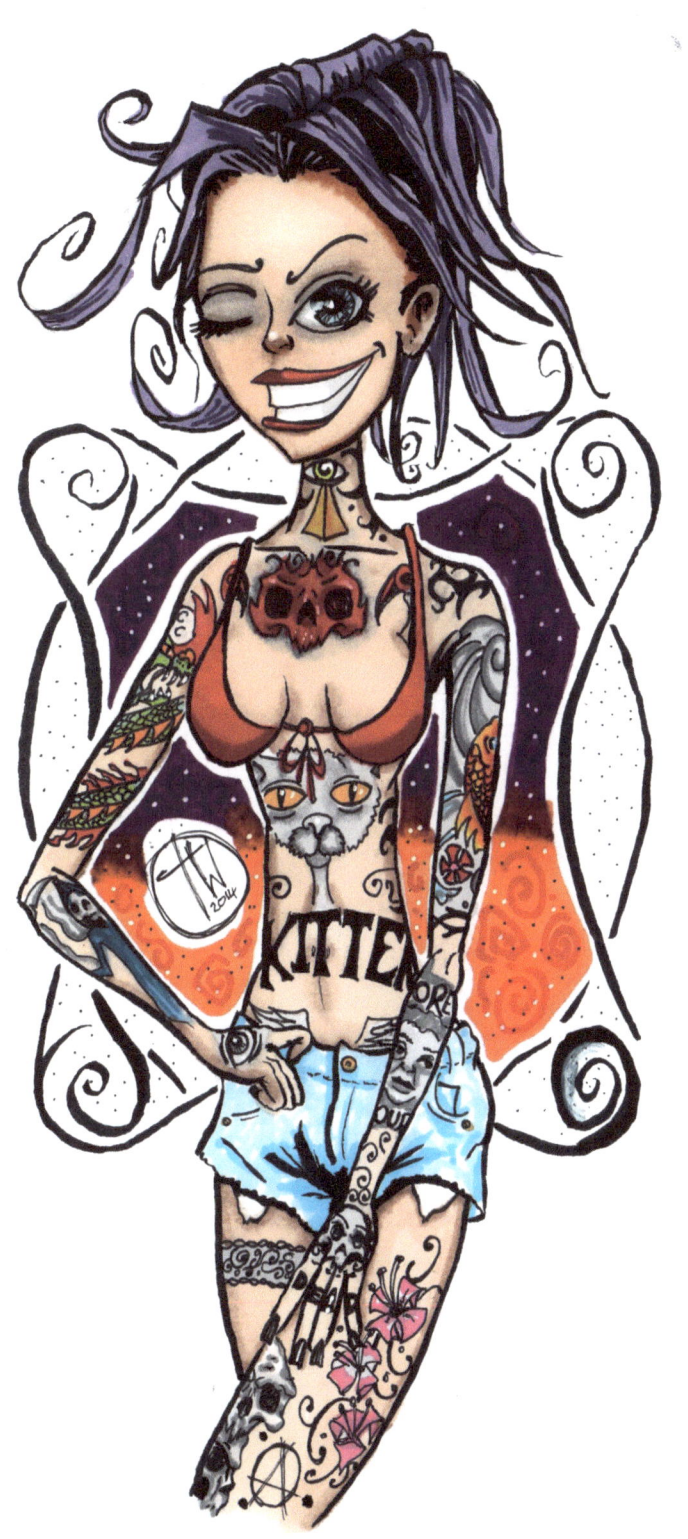

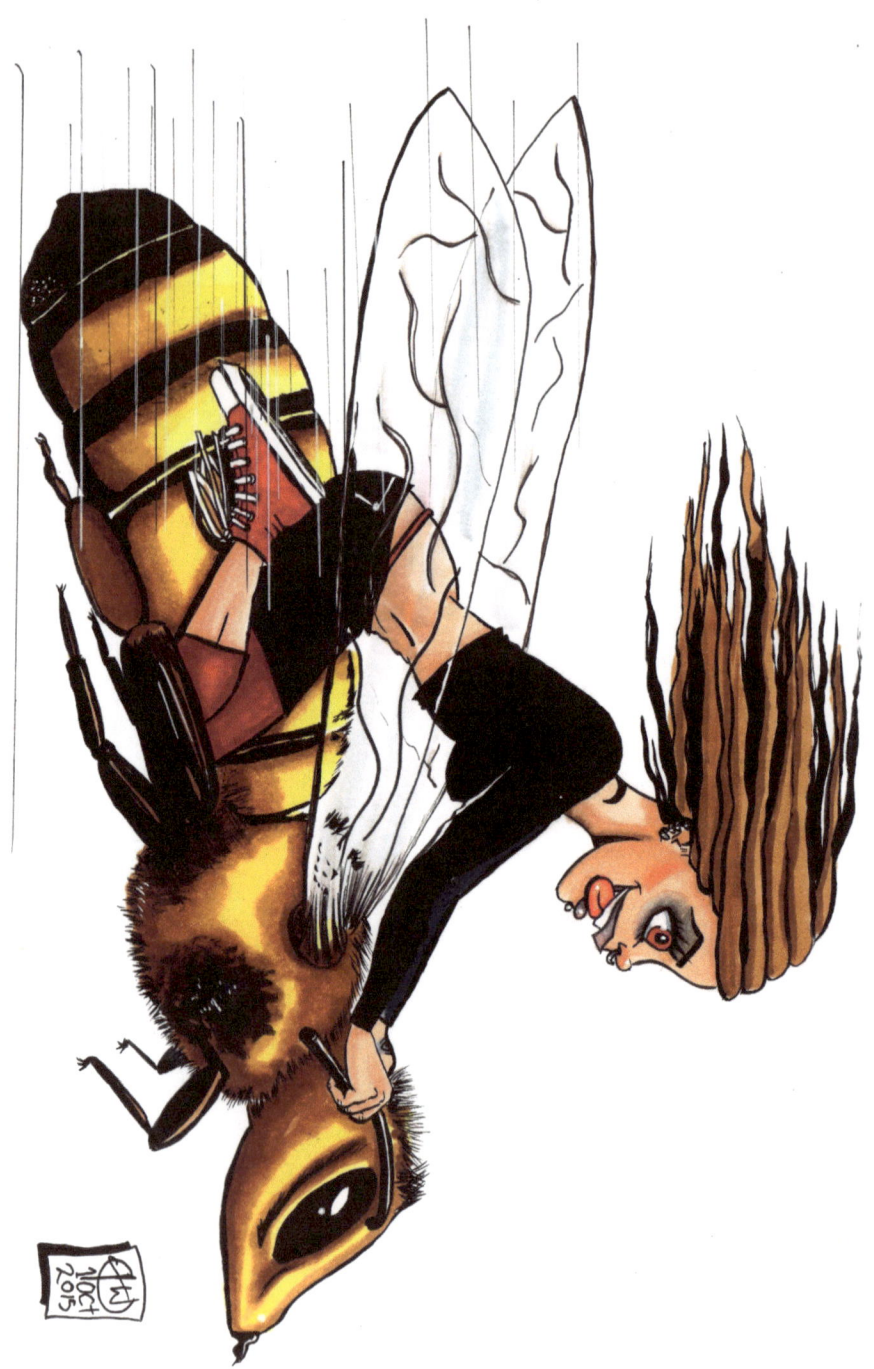

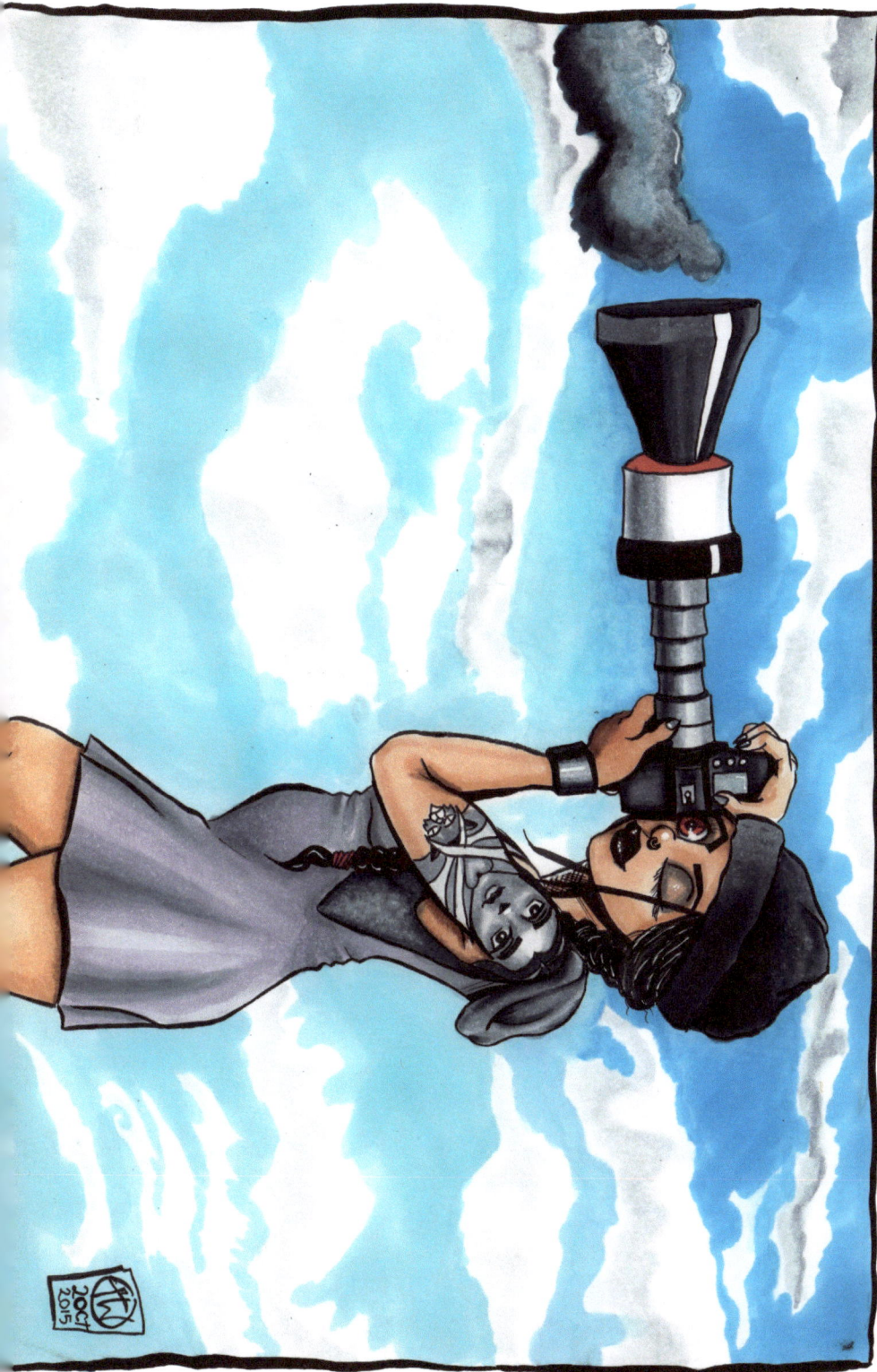

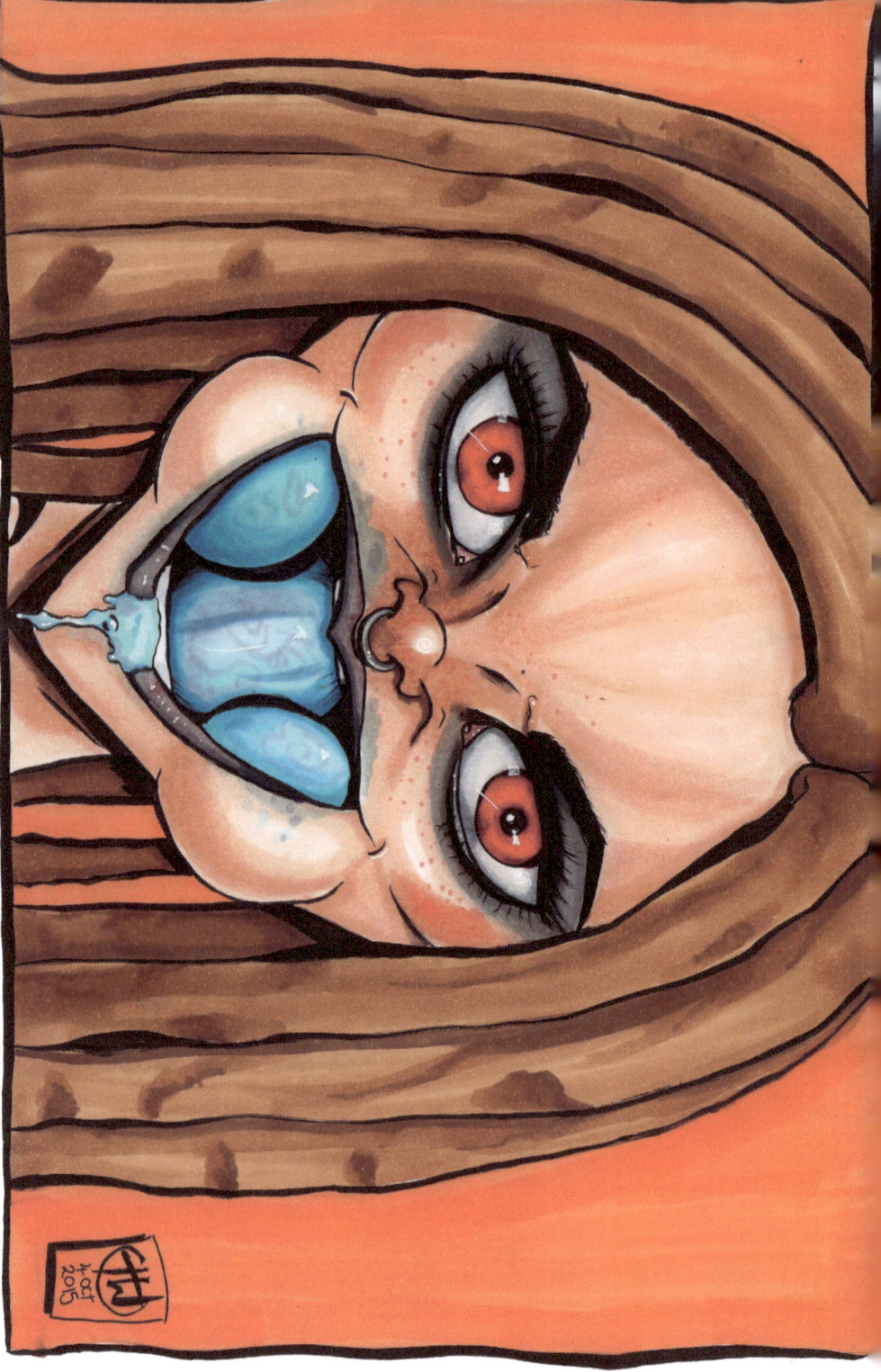

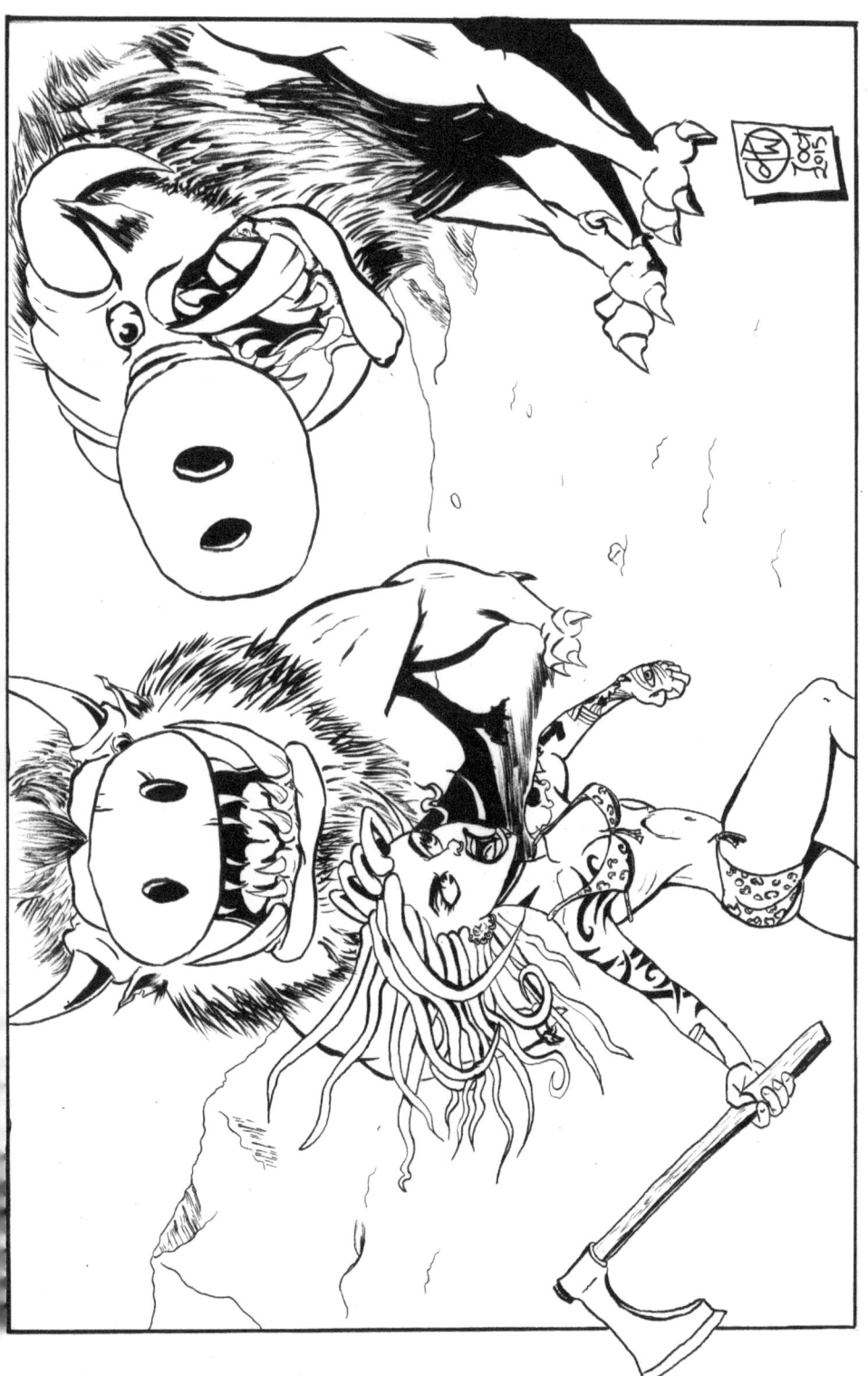

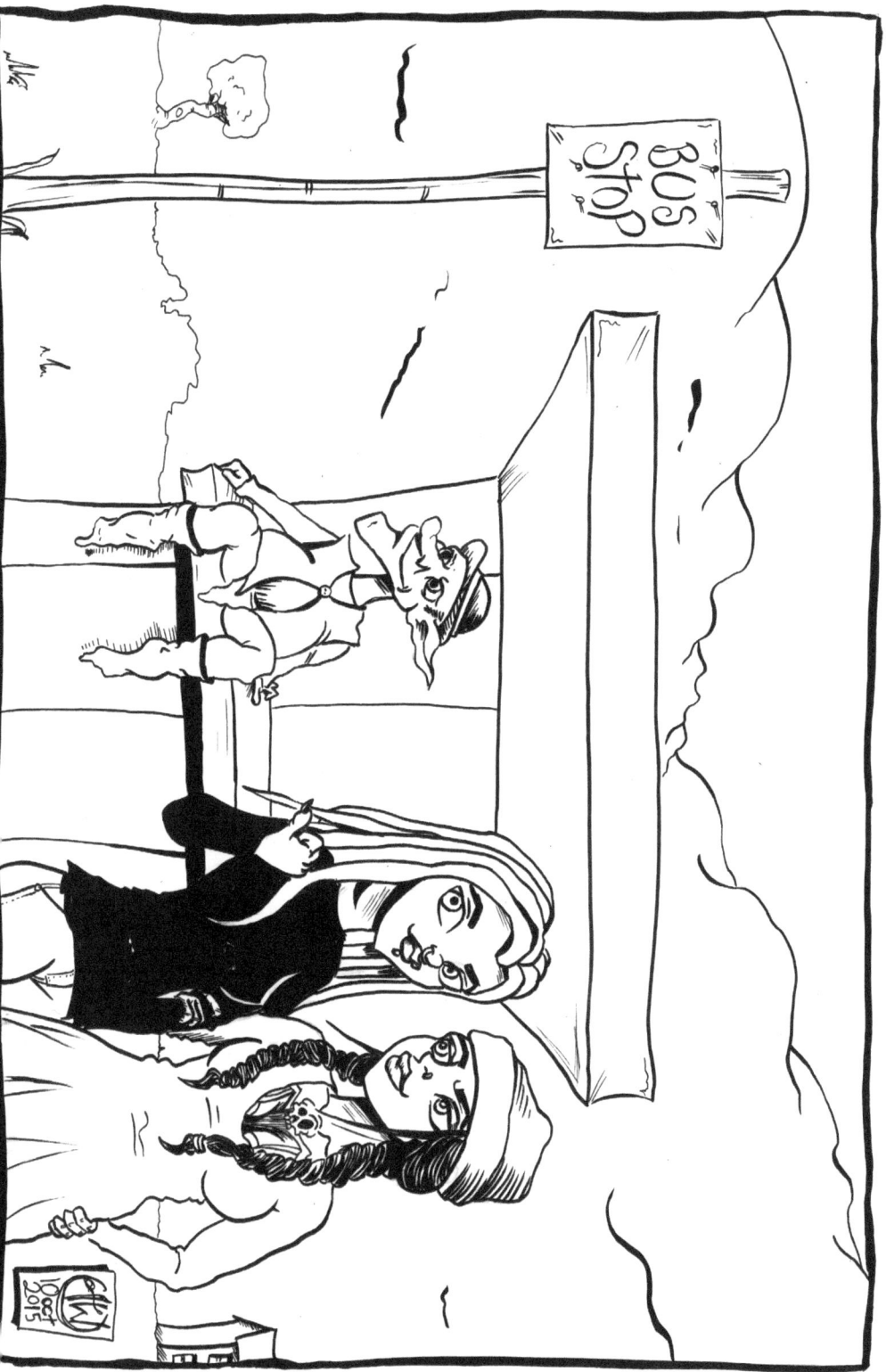

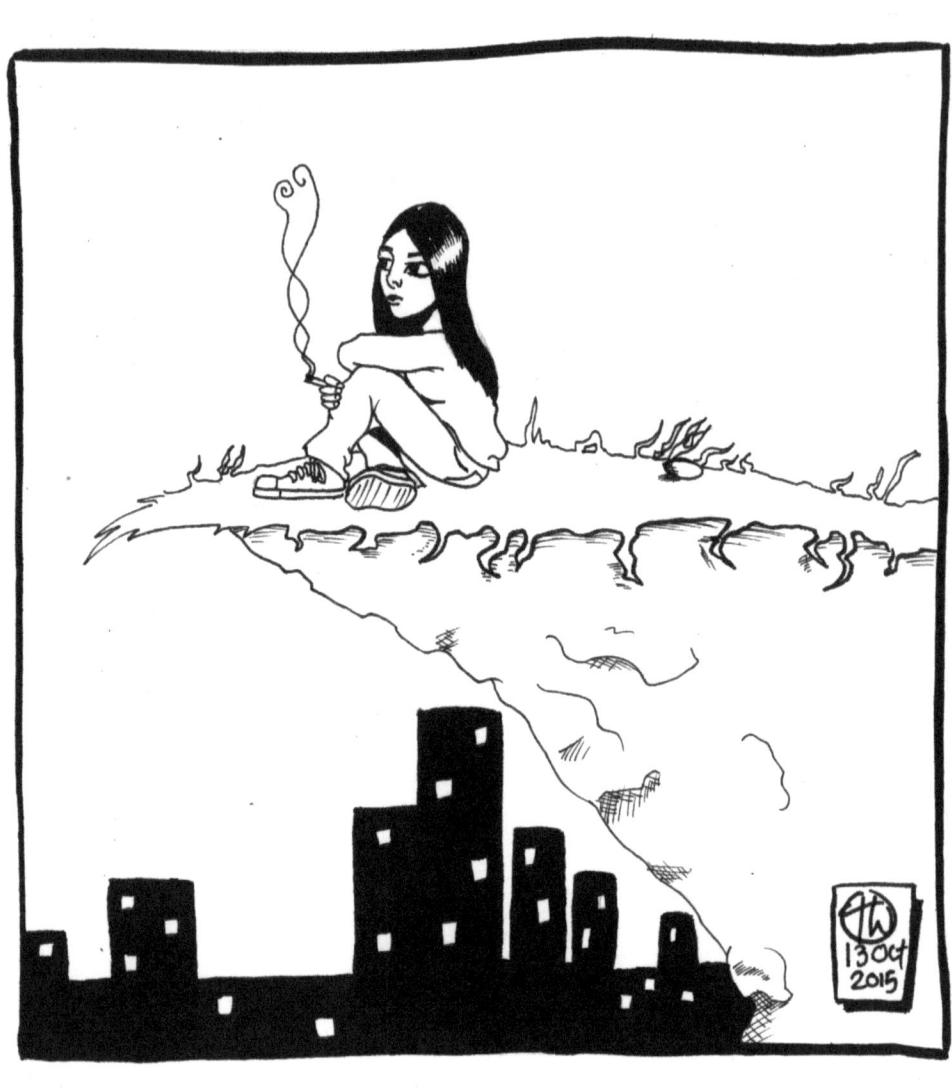

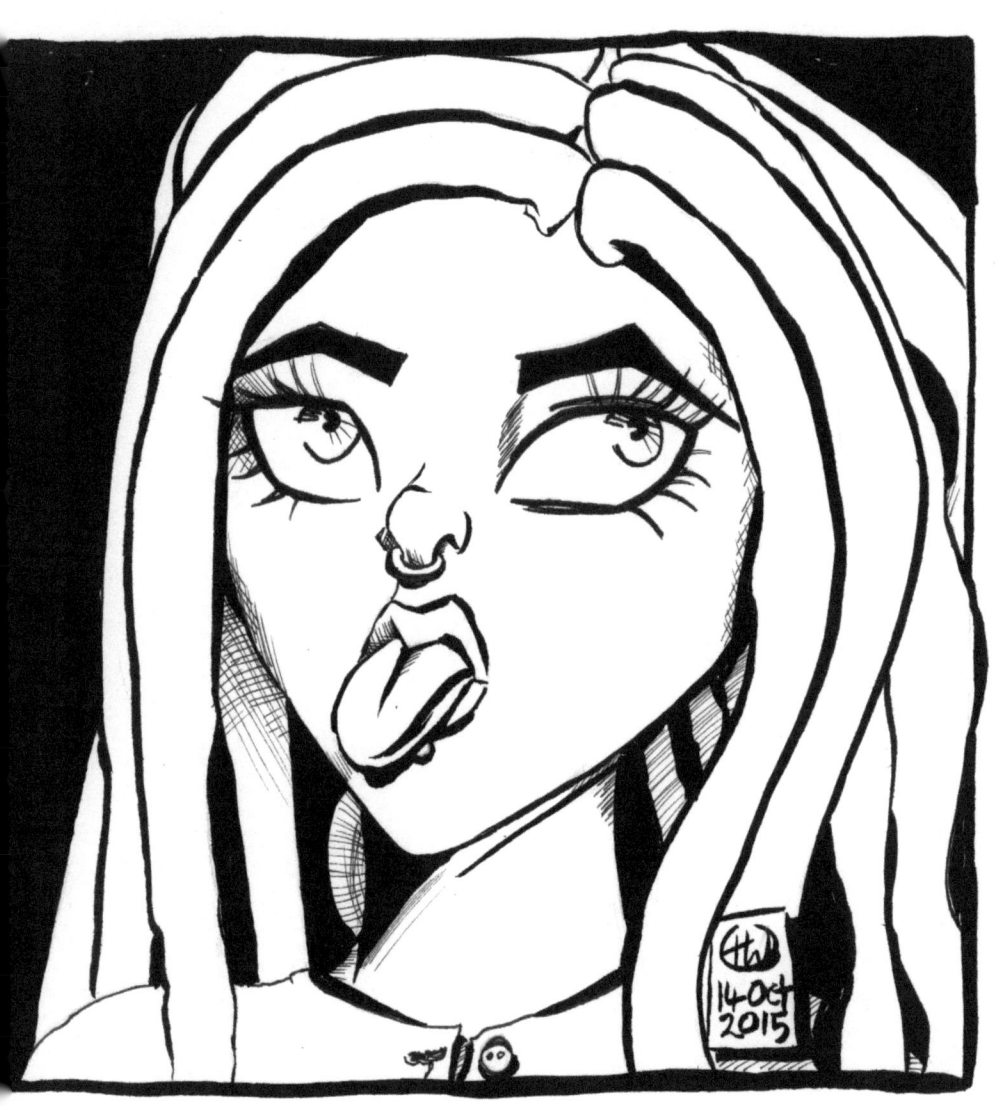

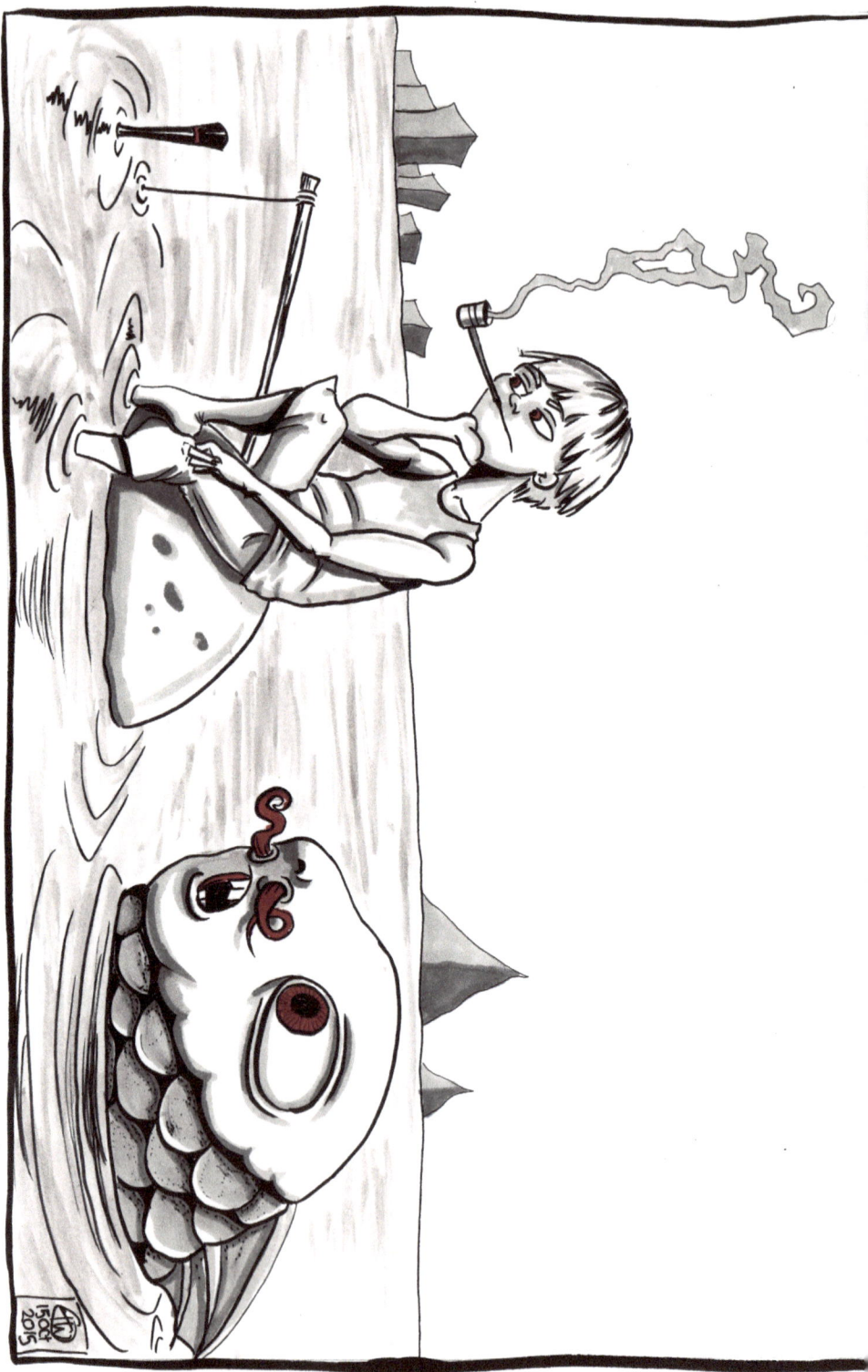

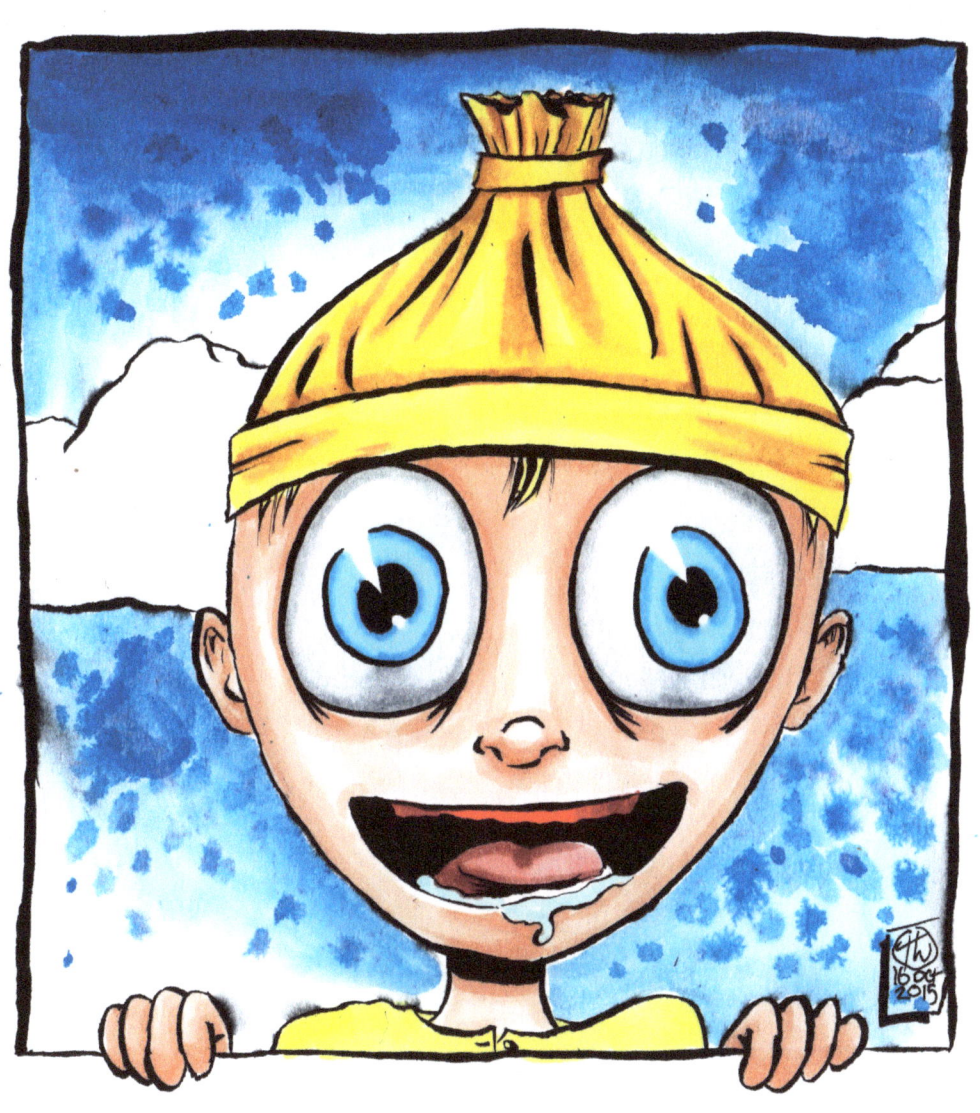

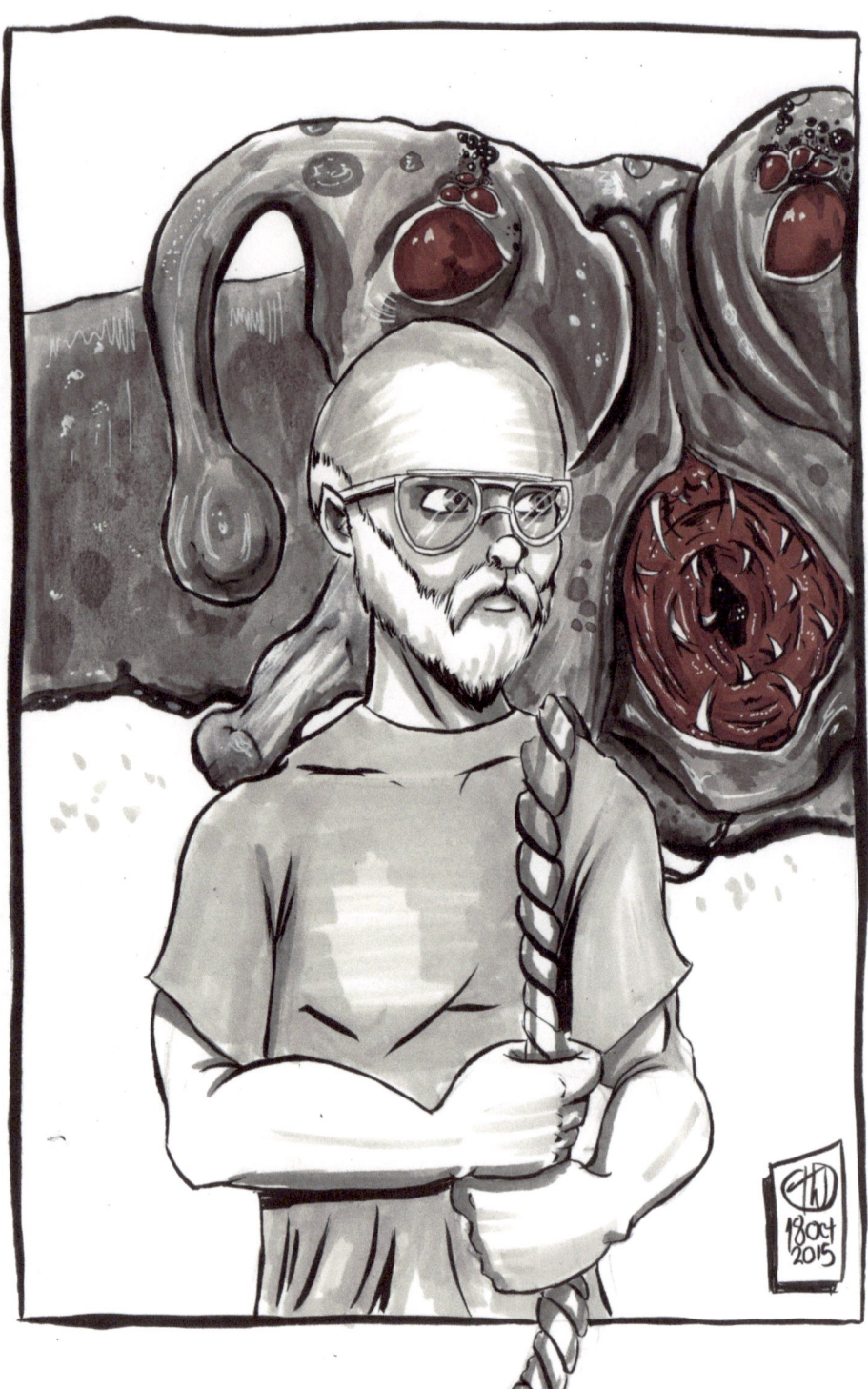

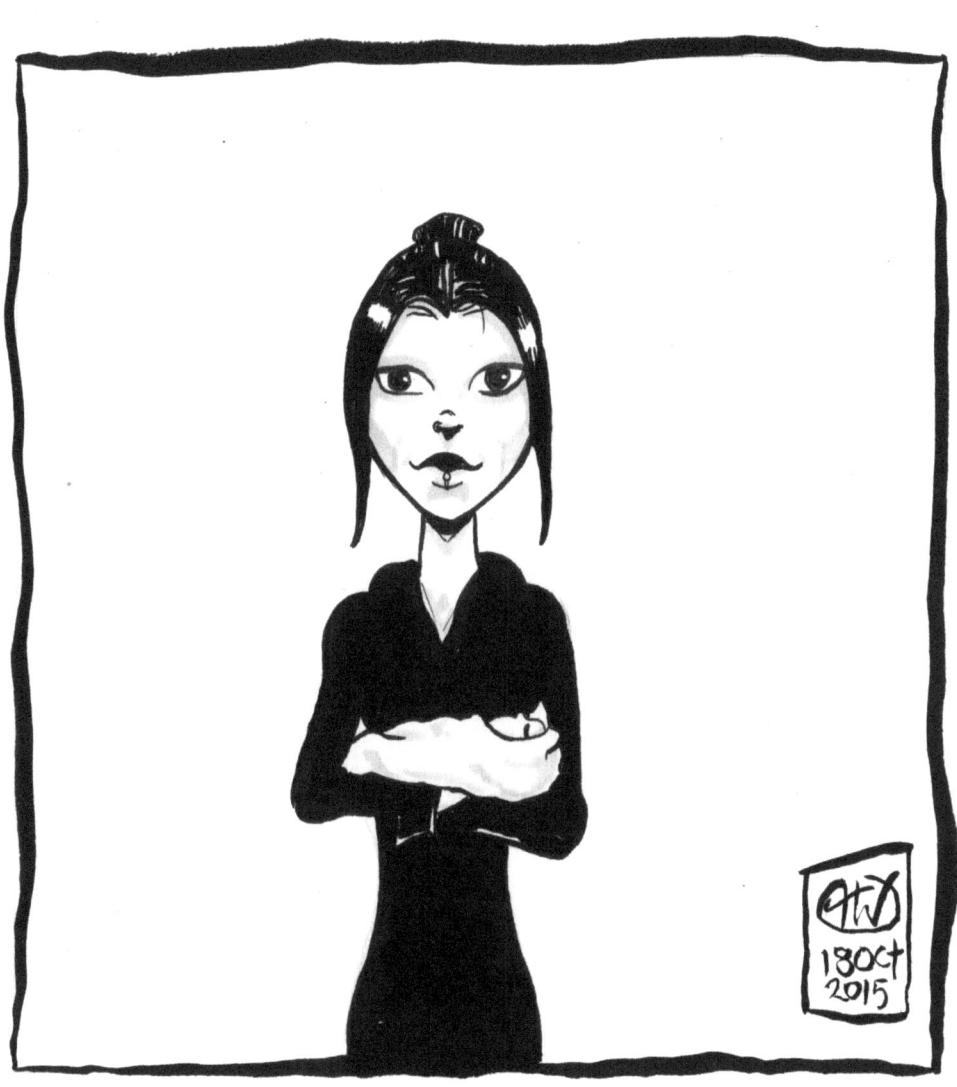

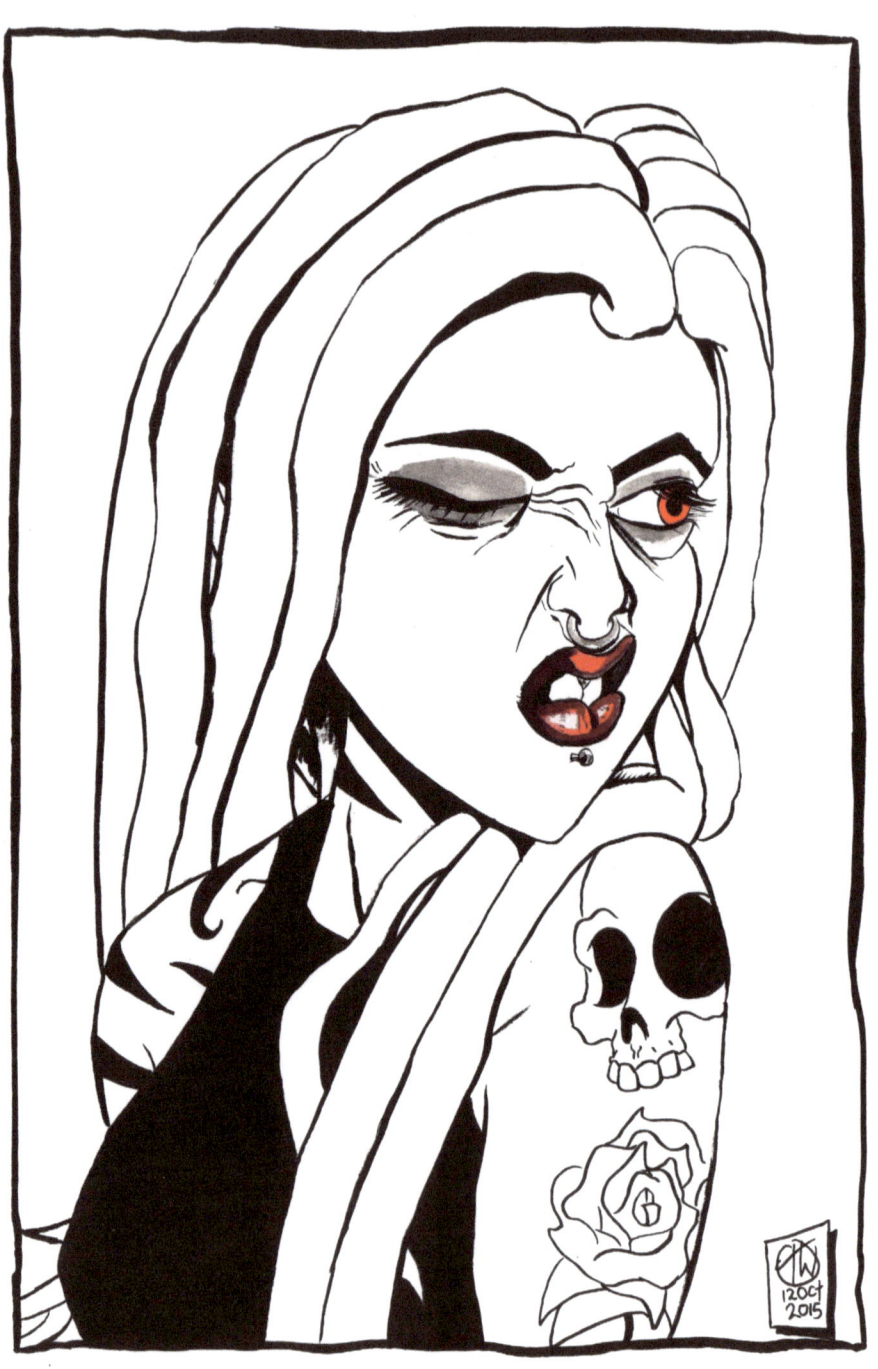

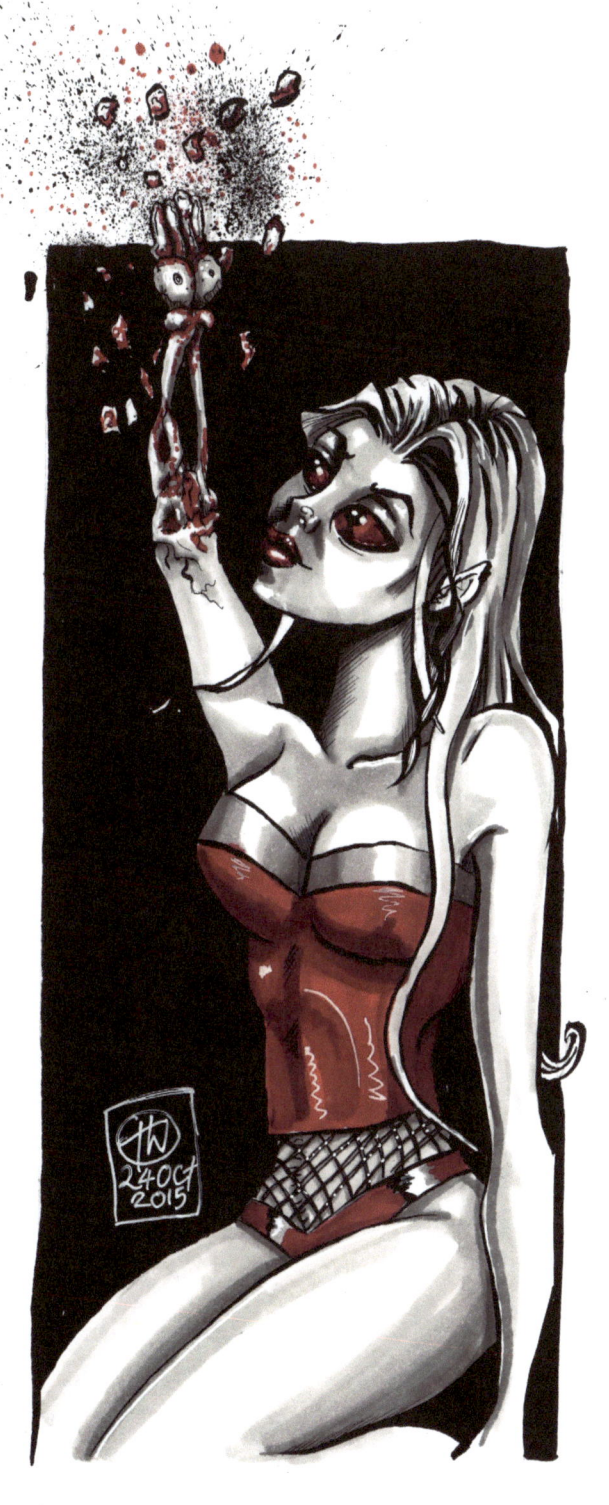

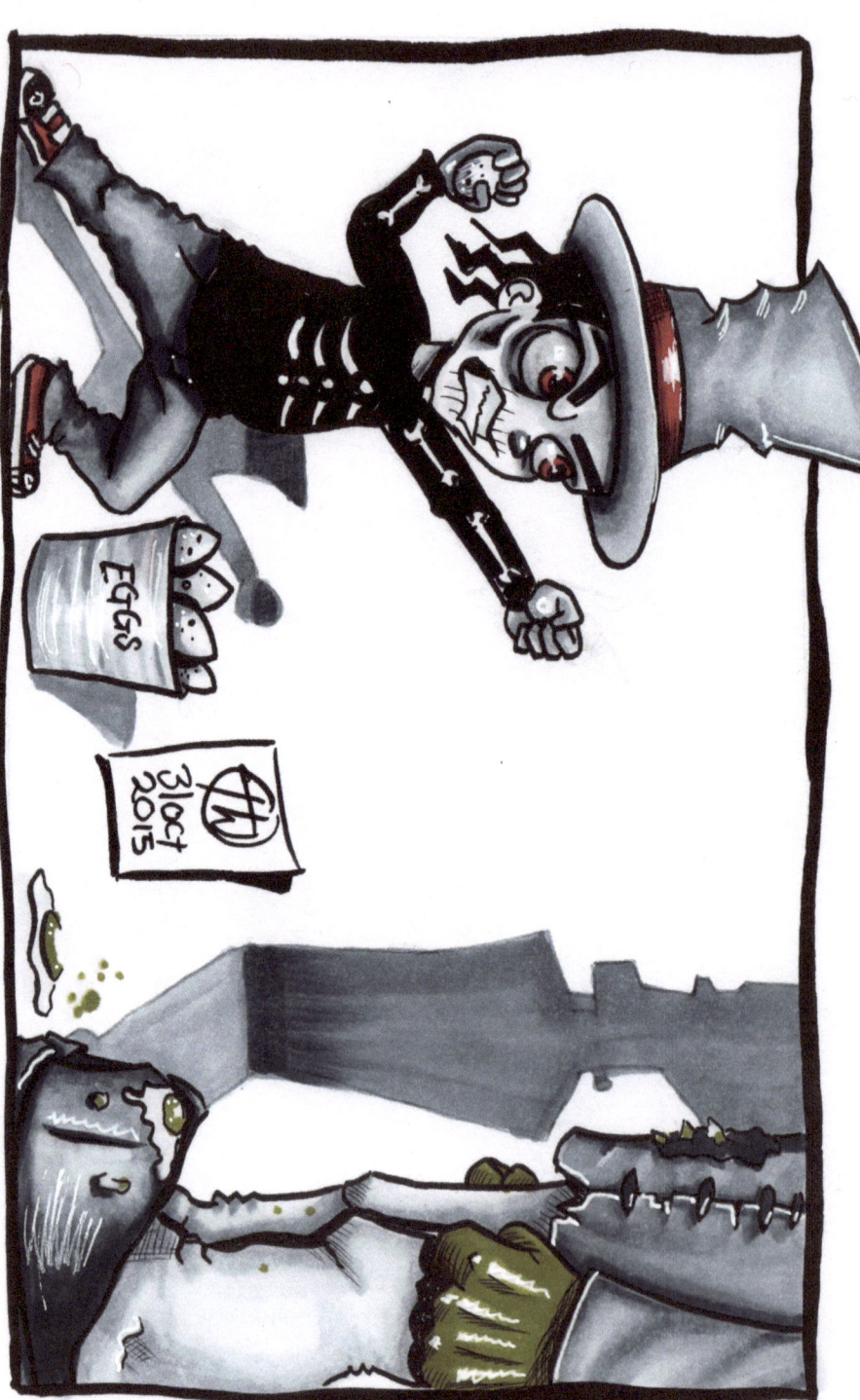

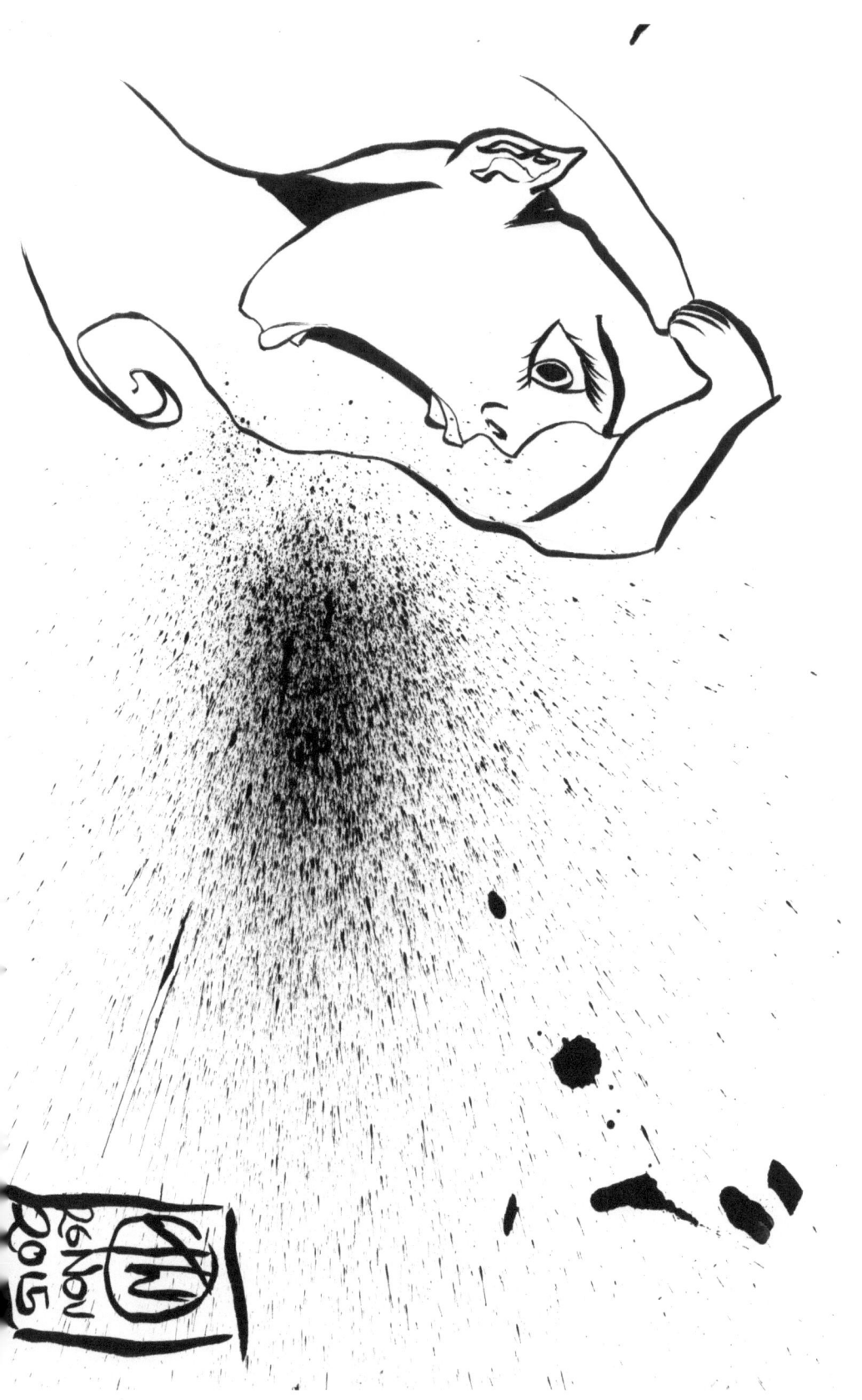

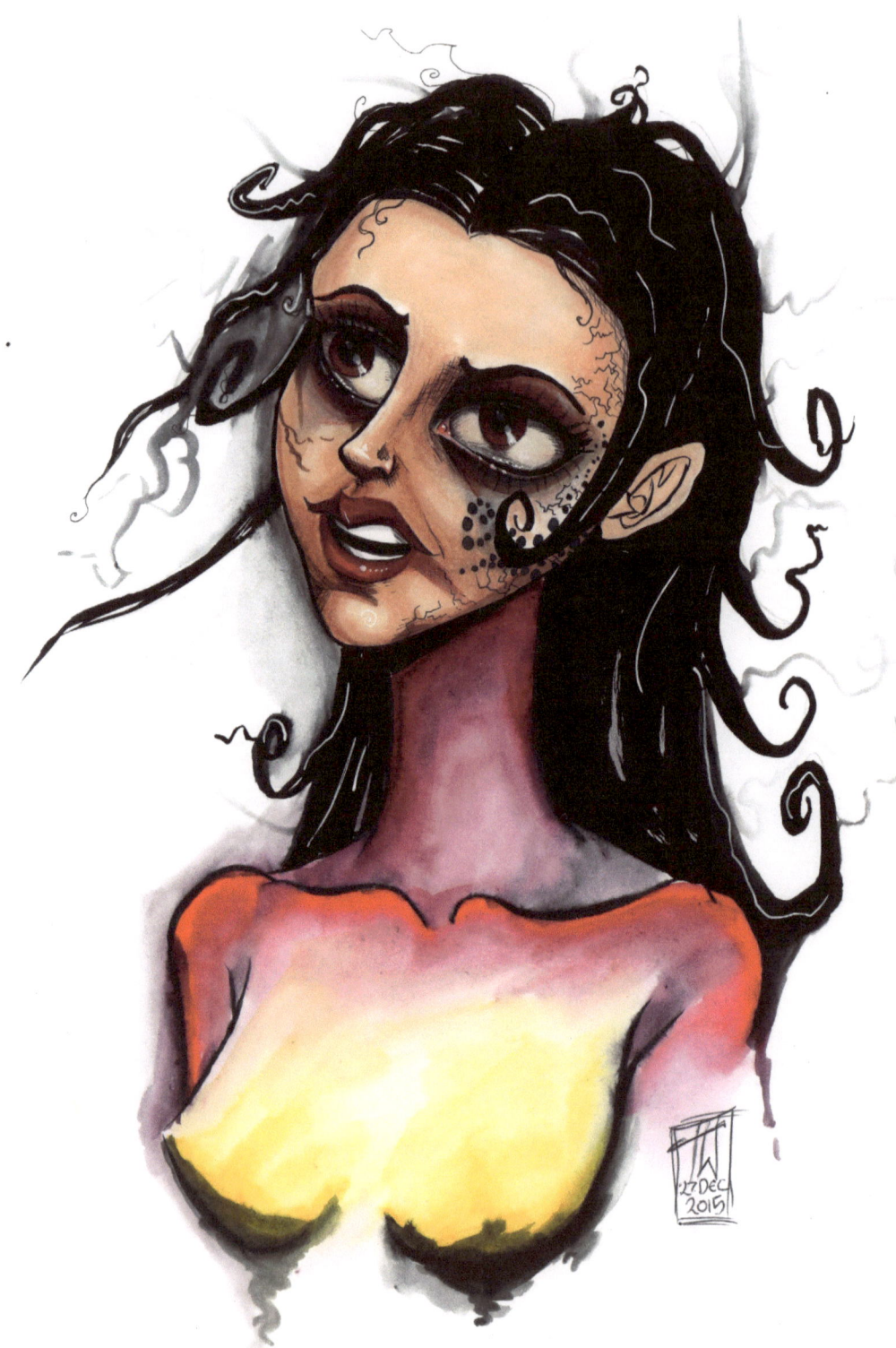

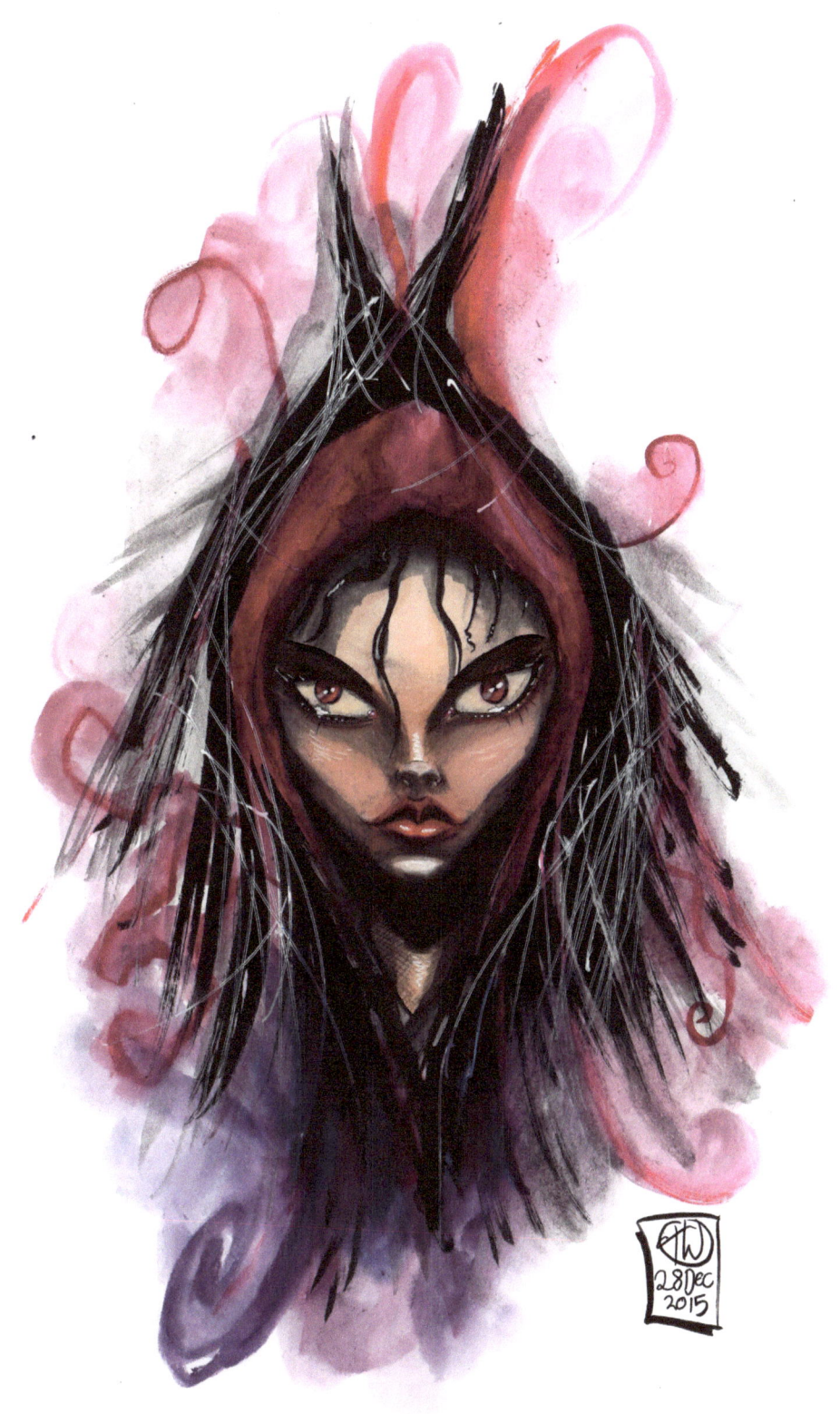

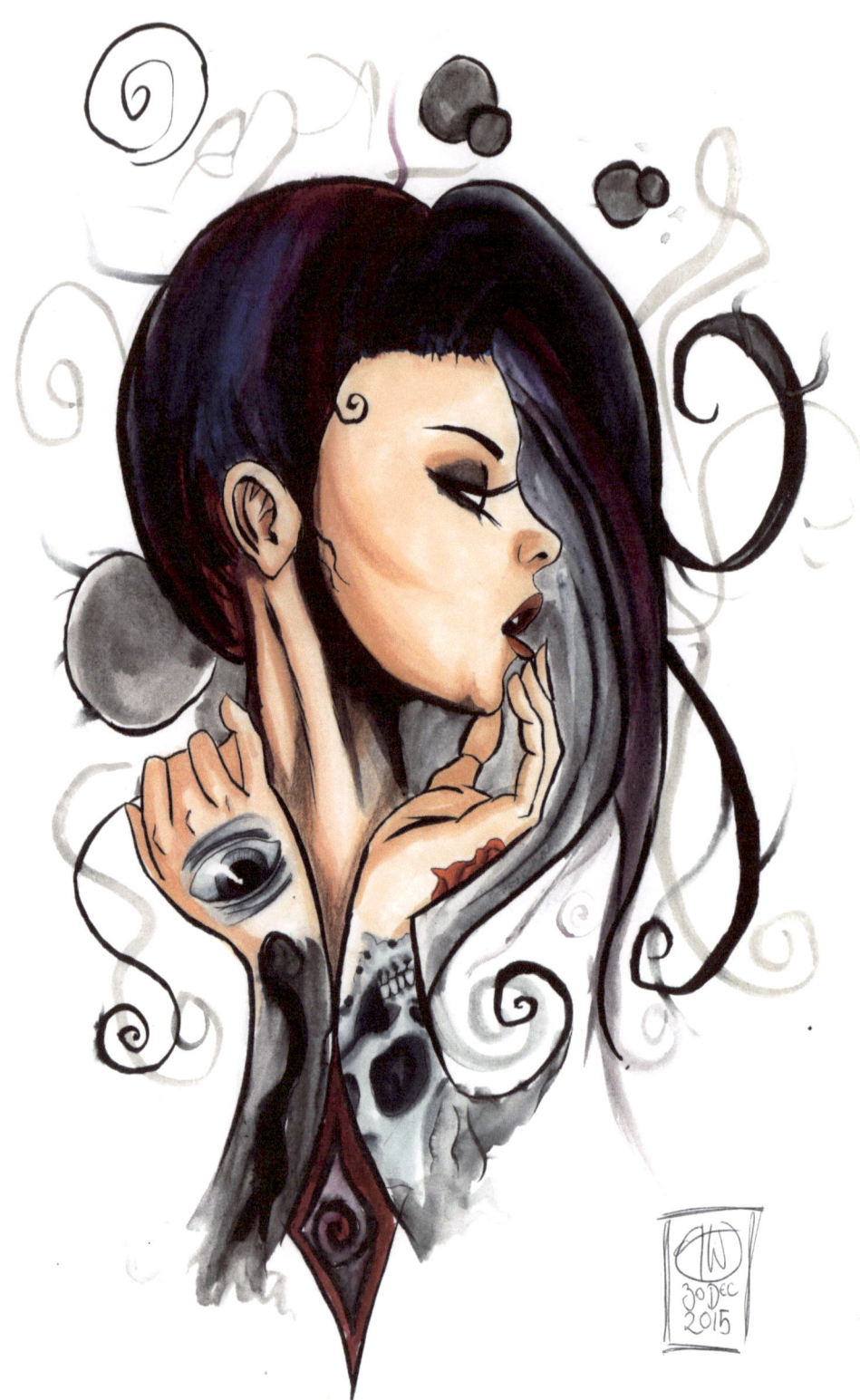

www.ingramcontent.com/pod-product-compliance
Lightning Source LLC
Chambersburg PA
CBHW040831180526
45159CB00001B/149